Christmas
with
NORMAN
ROCKWELL

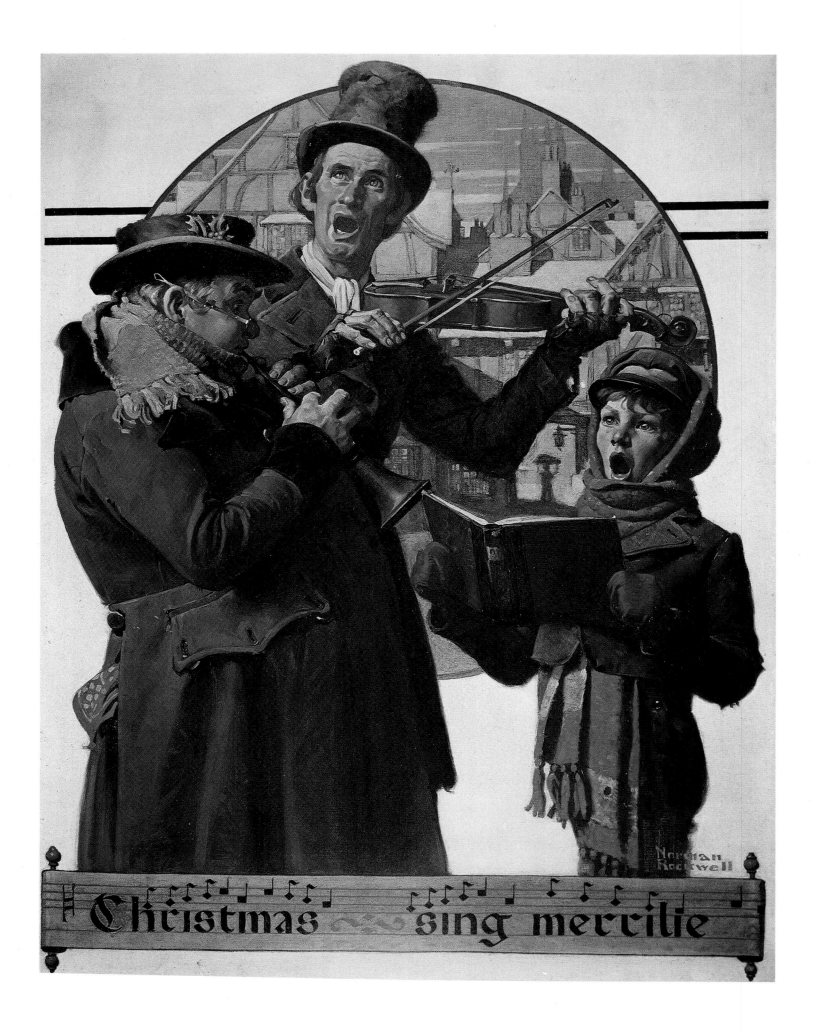

Christmas
with
NORMAN ROCKWELL

John Kirk

GALLERY BOOKS
An imprint of W.H. Smith Publishers Inc.
112 Madison Avenue
New York, New York 10016

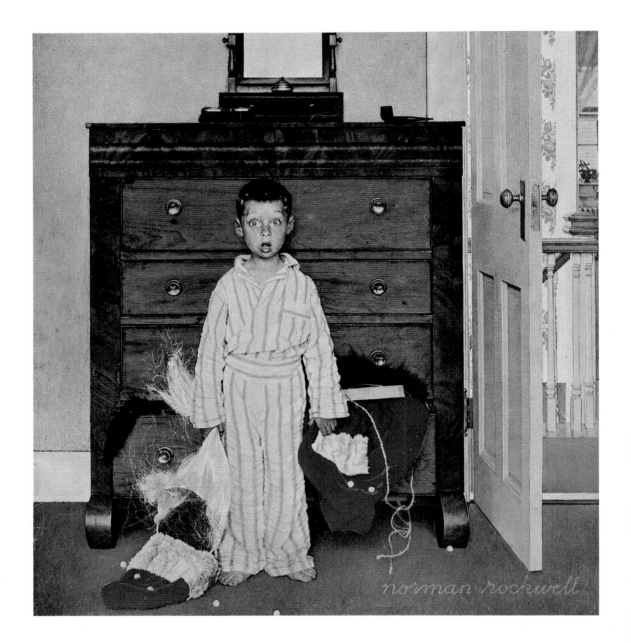

Published by Gallery Books
A Division of W H Smith Publishers Inc.
112 Madison Avenue
New York, New York 10016

Produced by
Brompton Books Corp.
15 Sherwood Place
Greenwich, CT 06830

ISBN 0-8317-7422-3

Printed in Hong Kong

10 9 8 7 6 5 4 3 2 1

Page 2: **Christmas . . . Sing Merrilie.** *Original oil
painting for a* Post *cover, December 8, 1923.*

This page: **Christmas, 1956.** Post *cover, December 29,
1956.*

CONTENTS

NORMAN ROCKWELL THE ARTIST

Every year for well over half a century Norman Rockwell presented to middle-class American magazine readers a cornucopia of images that reflected with uncanny accuracy aspects of the same experiences, sentiments and aspirations that made up their own daily lives. In the process Rockwell became the most widely known and best-beloved painter in the history of American art, a position he still securely occupies today, more than a decade after his death.

Always self-deprecating, Rockwell said of his own talent merely that he was able to paint "ordinary people in everyday situations, and that's all I can do." But of course there was much more to it than that. He was never just a reporter. What those people and scenes *represented*, and how Rockwell *felt* about what they represented, were the true themes of virtually every canvas he ever painted. The people, places and episodes he chose to depict were always meant to be distillations of something greater, emblems of a way of life – or, perhaps better, a way of living – that he genuinely and deeply loved.

It is hardly surprising, therefore, that Rockwell, in his constant search for epiphanies of the everyday world, should have been drawn to holidays, those special times of the year when family feeling, exuberance, warmth, nostalgia, humor, spontaneous kindness and much else that so attracted him in ordinary life tend to

Below: *Rockwell called this cartoon sequence, executed in the 1940s,* Norman Rockwell From the Cradle to the Grave. *The prediction made in the last picture – that Rockwell would do* Post *covers for the rest of his life – would not be fulfilled.*

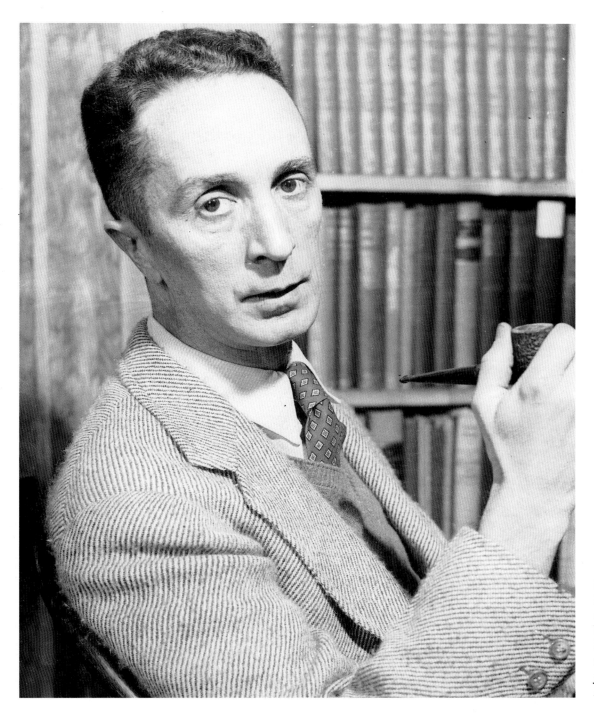

Left: *A portrait photo of Norman Rockwell made on July 14, 1950, a time when the artist was at the height of his powers and was by far the most famous cover illustrator in America.*

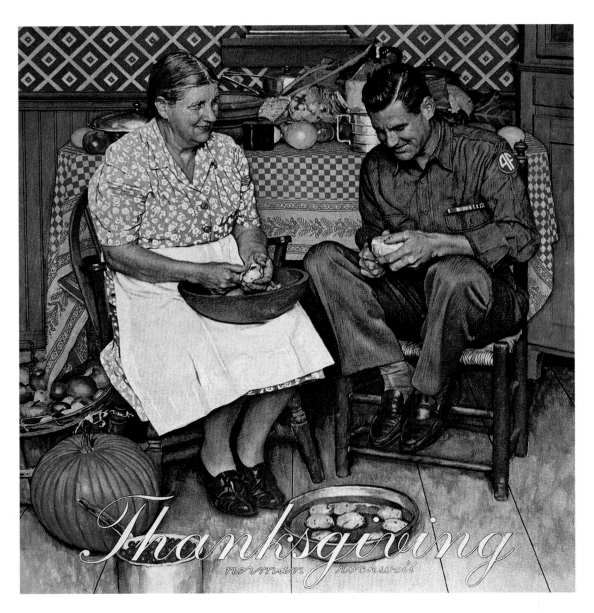

Right: *Thanksgiving was, after Christmas, the holiday cover theme for which Rockwell was best known. Usually, in any year when he painted a Thanksgiving cover for the* Post *he would not do its Christmas cover.*

be most concentrated. Certainly Thanksgiving, New Year's Day, Easter and many other celebrations inspired him to paint memorable canvases, but there is one holiday above all others with which his name is indissolubly linked in America's imagination.

Rockwell's Christmas paintings date literally from the beginning of his artistic career. His very first paying commission (he was then only 14 and still a student at the Chase School of Fine and Applied Art in New York) was to design four Christmas cards for Mrs. Arnold Constable. Within a few years national magazines, manufacturers and advertising agencies all over the country would be clamoring for his Christmas scenes, and would continue to do so for the rest of his life. His annual Christmas covers for *The Saturday Evening Post* became a kind of national institution, almost as much a part of the season's rites as lighting the tree and exchanging presents. The Christmas cards he created for Hallmark in the 1940s and 50s were among the most popular in the company's history, as were the seasonal calendars he designed for Brown and Bigelow during the same period. So identified with this one season did Rockwell become that a number of his canvases which contain no explicit references whatever to Christmas – various generic winter scenes, for example, and even some scenes that lack *any* seasonal signature – are nevertheless thought of by enough people as being "typical" Rockwell Christmas paintings so that they continue to be reproduced at Yuletide year after year.

How are we to account for the overwhelming popularity of Rockwell's Christmas paintings? Doubtless there are several explanations, some relating to his own exceptional painterly talents and others to the ways in which they were displayed and promoted in the media he served. But surely one of the most basic explanations must have to do with the unmistakable sincerity with which he approached the subject of Christmas – and indeed all subjects that moved him. Early in his career (1923) he remarked to an interviewer, "People somehow get out of your work just about what you put into it, and if you are interested in the characters that you draw, and understand them and love them, why, the person who sees your picture is bound to feel the same way." The fact is that Rockwell sincerely loved Christmas, loved its spirit and all the various touching, amusing and uplifting effects it has on people, and his genius was to make us, through the ancient sorcery of paint on canvas, "feel the same way."

Norman Rockwell, contrary to what many people casually assume, was neither a country boy nor a middlewesterner. He was in fact born in New York City in 1894 and lived there until he was nine. When his family did finally move out of New York in 1903, it was only to the not-very-distant suburb of Mamaroneck in southern Westchester (though, to be sure, the Mamaro-

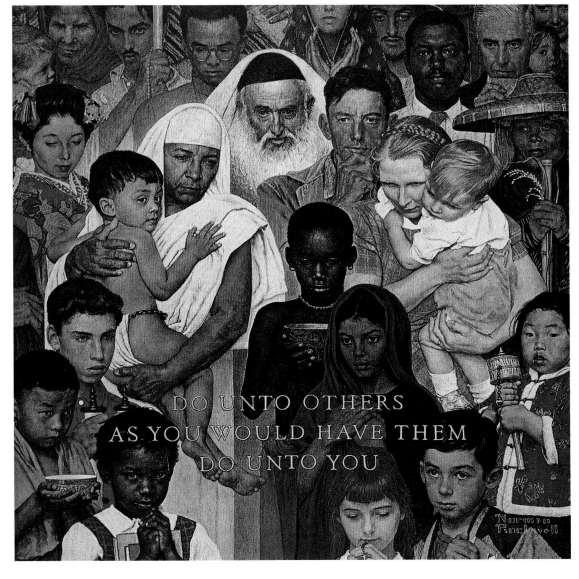

Left: *Many of Rockwell's paintings which are now regularly reproduced at Christmastime were not originally executed with Christmas in mind. His* The Golden Rule *cover for the April 1, 1961, issue of the* Post *is a case in point.*

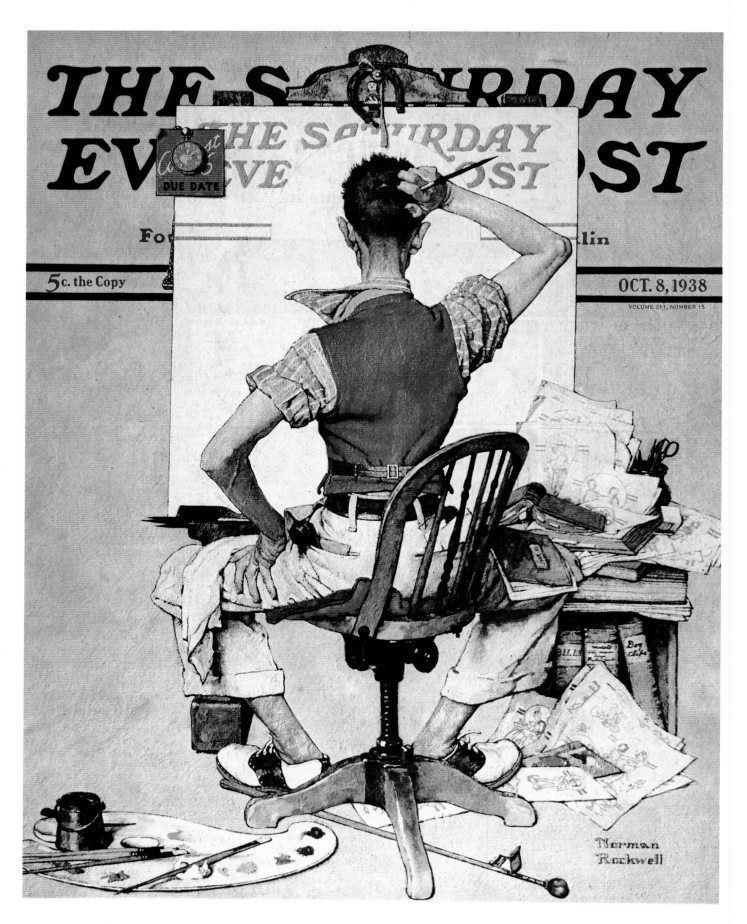

Above: *A typical non-holiday Rockwell cover for the* Post. *Note the allusion to this painting in the cartoon sequence reproduced on page 6.*

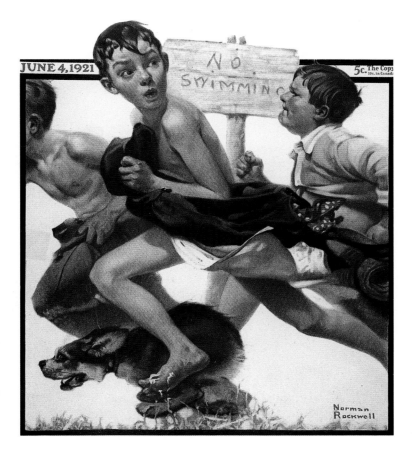

JUNE 4, 1921

NO SWIMMING

5c. The Copy 10c. in Canada

Norman Rockwell

Right: *In Rockwell's first decade as a* Post *cover artist (1916-26) the great majority of his paintings featured children. One of his most popular was this June, 1921, cover.*

neck of 1903 was a far more rural place than it is today), whence his father commuted to his workplace, a textile firm, back in the city. Within five years of the move young Norman was himself commuting, first twice a week to New York's Chase School of Fine and Applied Art and then, after a year, daily to the prestigious National Academy School.

The evolutionary stages that had brought Rockwell to the status of full-time art student were fairly straightforward. Like many young children he had early developed a penchant for sketching, but in his case it was a penchant that, far from fading away with the onset of other interests, grew steadily stronger as the years passed. Moreover, it was clearly a penchant that was married to genuine talent, though how extensive a talent, only the discipline of formal training could reveal. Rockwell's parents understood this and raised only mild objections when he decided to drop out of high school in order to attend the National Academy School, but since the family lacked the money to cover his tuition, it was also understood that Rockwell would have to help pay his way by taking jobs on the side.

Earning extra cash proved no great problem for Rockwell, but the curriculum at the National Academy did. A bastion of conservatism, the Academy School obliged its students to spend endless hours making charcoal studies from plaster casts of classical sculpture. And even when the long-suffering students were at last permitted to attend life classes, the pervasively academic atmosphere of the place remained stultifying. To his credit and ultimate great good fortune, Rockwell rebelled, and the next year (1910) he transferred to the Art Students League.

The League was at that time one of the most stimulating and progressive art schools in the world. Although it trained artists of all kinds, it was particularly strong in teaching illustration. Indeed, one of its founders was Howard Pyle, a man whom many have called "the father of American illustration" (and who was then, and would always remain, one of Rockwell's great heroes). Perhaps inevitably, Rockwell gravitated to the League's illustration classes, then under the capable and often inspiring direction of Thomas Fogarty, but Rockwell was also fortunate

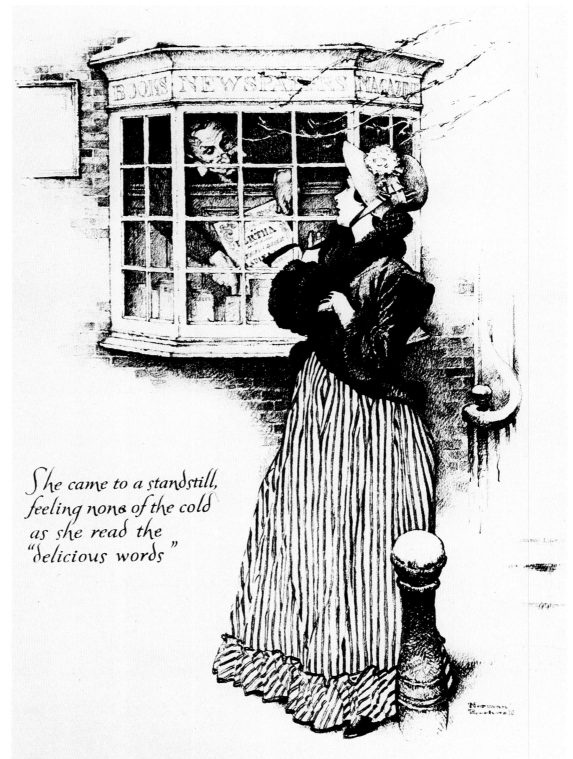

She came to a standstill, feeling none of the cold as she read the "delicious words"

Right: *Although he is best known as a cover artist, Rockwell was a highly skilled interior illustrator as well, as shown in this graceful sketch for a series on Louisa May Alcott that appeared in* Woman's Home Companion *in 1937-38.*

in having as his professor of artist's anatomy George Bridgeman, arguably the greatest teacher of that subject ever produced by this country.

Under such instruction Rockwell's talents blossomed – and not only in the classroom. The League School in general, and Fogarty in particular, encouraged students to seek extracurricular paying assignments so that they might better learn how the world of commercial art really operated. Rockwell thus obtained his first major commission – to provide 12 black-and-white illustrations for C. H. Claudy's *Tell-Me-Why Stories About Mother Nature* – when he was still only 17, and other assignments quickly followed.

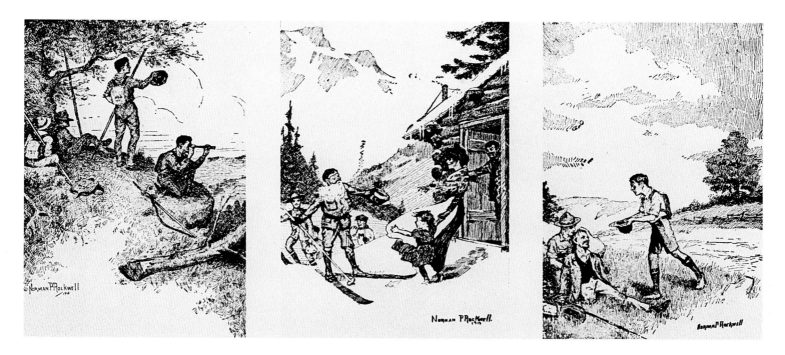

By the time he was 19, and barely out of the League School, Rockwell had become both the art editor of, and principal art contributor to, *Boys' Life*, the official magazine of the Boy Scouts of America, an organization to which he would ever after be devoted. At the same time, he was doing an increasing volume of work for other publications, mainly children's magazines such as *Saint Nicholas, Youth's Companion* and *Harper's Young People*. He was, in short, busy, successful and earning extremely good money. But for all that, he was still, as far as the great world of illustration was concerned, distinctly a junior varsity player.

Above: *Among Rockwell's earliest surviving works are these illustrations that he drew for the* Boy Scouts Hike Book *in 1913 and the* Boys Camp Book *in 1914.*

American illustration had entered a Golden Age with the advent of the twentieth century. The reason for this had as much to do with technology as with talent. Certainly, there had been no shortage of great illustrators working before 1900 – names such as Winslow Homer, Frederic Remington, Charles Russell, Charles Dana Gibson and Howard Pyle spring readily to mind. But the printing processes with which mid-nineteenth-century illustrators had to cope were not, in their essentials, much advanced over those known to Albrecht Dürer in the fifteenth century. At least as far as magazines and most books were concerned, the reproduction of illustrations had to be both monochrome and either solid-color or linear; the reproduction had to be subject, in other words, to almost exactly the same limitations as a pen-and-ink sketch. Any original work of art involving graded half-tones had to be laboriously (and not always accurately) hand-copied on an engraving block – the half-tones being rendered either as hatching or stippling, according to the engraver's fancy – and it was this copy, not the original, that was reproduced. But in the 1880s this venerable and unsatisfactory process was at last undone by the advent of a revolutionary new technique called photoengraving. Now, by entirely mechanical means, a photograph of a piece of art could in effect be engraved directly on the printing surface, which would then not only retain all the photograph's accuracy but could, like the photograph, display a full range of graded half-tones. Best of all, the new technique opened up dazzling possibilities for full-color reproduction, possibilities that were quickly exploited and would be well-advanced by the time Rockwell began his professional career.

The photoengraving revolution gave illustrators a freedom and a power of address never before known, but simultaneously it placed the most exacting demands on their skills. There could now be no question of blaming engravers for weak draughtsmanship or of neglecting to master the dimension of color in com-

Left: *The unmistakable sleek Art Deco style of J.C. Leyendecker is well displayed on this 1936* Post *cover.*

Opposite top left: *A portrait photo of the great Howard Pyle, whom many call the "father of American illustration."*

Opposite top right: *One of several major American artists who began as illustrators was Winslow Homer.*

position. Illustrators were being put on their mettle to a degree that few had previously experienced.

The man most responsible for helping American illustrators make this difficult, exciting transition was Howard Pyle. Not only did he exploit the possibilities offered by the new technology with exemplary brilliance in his own work, he was a tireless and wholly extraordinary teacher who personally trained (without fee) many of the best young illustrators of the rising new generation, while inspiring all the rest. His standards were, as he knew they had to be, very high. "My final aim in teaching," he said, "will not be essentially the production of illustrators of books but rather the production of painters of pictures, for I believe that the painters of true American art are yet to be produced."

Thanks largely to Pyle's examples and precepts, the first two decades of the twentieth century witnessed a creative explosion that not only laid the foundations of modern American illustration but established it virtually overnight as a major popular art form. Some of the artists who contributed to this revolution were, like Pyle, older men, born in the 1850s and 60s and brought up in the old techniques, who nevertheless made the transition into the new world of photoengraving with grace and authority: Edwin Austin Abbey, Arthur Frost and Edward Penfield were representative of this group. But more important was the younger generation of artists who, born in the 1870s or early 80s, had either been trained directly by Pyle or were otherwise deeply indebted to his influence. Their work was received enthusiastically by the public, which rewarded many of them with a degree of celebrity unheard of in earlier times. Some of them, such as N.C. Wyeth, James Mont-

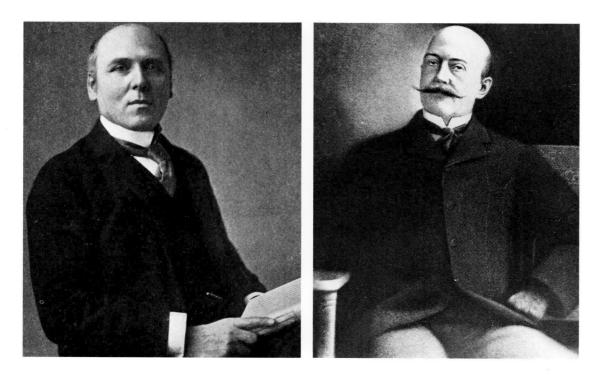

gomery Flagg, Maxfield Parrish, Frank and Joseph Leyendecker, Howard Chandler Christy and Harvey Dunn, are still famous. Others, such as Walter Biggs, Coles Phillips, Frederic Grunger, Frank Schoonover and Arthur William Brown, are now largely forgotten but were immensely influential in their own day. But one thing all these artists had in common was the exceptionally high standards they

Left: *A portion of an interior spread that Rockwell did for the* Post *in 1948. It was part of a series which bore the title "Norman Rockwell Visits . . ." and which proved immensely popular with readers.*

Right: *Rockwell was a meticulous craftsman, sometimes laying out compositions in great detail. This elaborate sketch for a* Post *cover was only an intermediate version. For the final result see page 8.*

maintained, standards that would be a truly daunting challenge to the "takeover" generation of young artists then waiting in the wings. These were the men who had been born in the 1890s and the early years of the twentieth century, men who were either still in art school or just embarking on their careers, men like Norman Rockwell.

Very early in his professional life Rockwell had received commissions in all of the three main branches of illustration: advertising, interior and cover. Each had its peculiarities. Advertising illustration, which tended to be restricted to showing products or scenes of people using products, was by a considerable margin both the best-paying and the most confining. It was the type of illustration Rockwell liked least, and though he accepted many such commissions during his lifetime, his antipathy towards advertising illustration waxed over the years. By the early 1960s he could write: "To many illustrators, including myself, I feel that it [the influence of advertising agencies] was a corrupting one. The temptation of their big budgets took away the kind of integrity that earlier artists like Howard Pyle had brought to their work."

Pyle, himself, had excelled in interior illustration, that is, illustration that illuminates an author's text, whether fiction or nonfiction. This was in some ways the most challenging branch of the art, for it required both a sensitivity to the structure of prose – an ability to identify key characters and scenes – and the imagination, skill and versatility to create dramatic images that faithfully represented an author's intentions. Rockwell liked this kind of illustration and was extremely

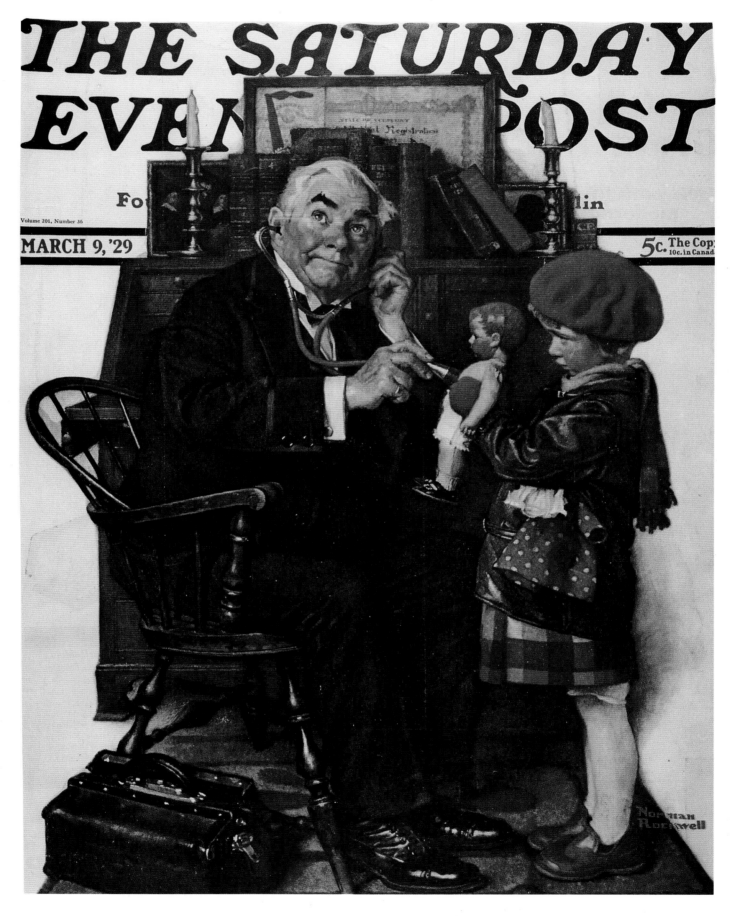

Doctor and Doll, *one of Rockwell's most popular* Post *covers, was painted for a March issue but has since often been reproduced at Christmas.*

good at it, but he also had some reservations about it. For one thing, in the early days (and even into the 1920s), unless the interior illustrator had the commanding stature of a Howard Pyle, his work was very likely to be reproduced both small and in black-and-white. But more basically, Rockwell never felt completely at ease illustrating other people's ideas and feelings, and it was probably for this reason as much as any other that almost from the beginning of his career he was drawn to painting covers.

Illustrations on magazine covers, because they served as a form of advertisement for the magazines in question, were almost always printed in color and given as large a display space as possible. And since, unlike interior illustrations, they were not tied to any specific text, they were free to tell their *own* stories, as accessibly and powerfully as possible. In this sense they permitted the artist a particularly direct form of communication with his audience, unadulterated by the thoughts of authors or the motives of advertisers. Deep down, this communication was what Rockwell most wanted.

Yet there were limitations here, too, especially in the early days. No one – magazine publishers, editors, art directors or cover artists – really knew how broad a range of stories readers wanted to be told on their magazine covers. The magazines' tendency was therefore to play it safe, to stick to a few tried and true themes that seemed to carry the least risk of provoking indifference, incomprehension or,

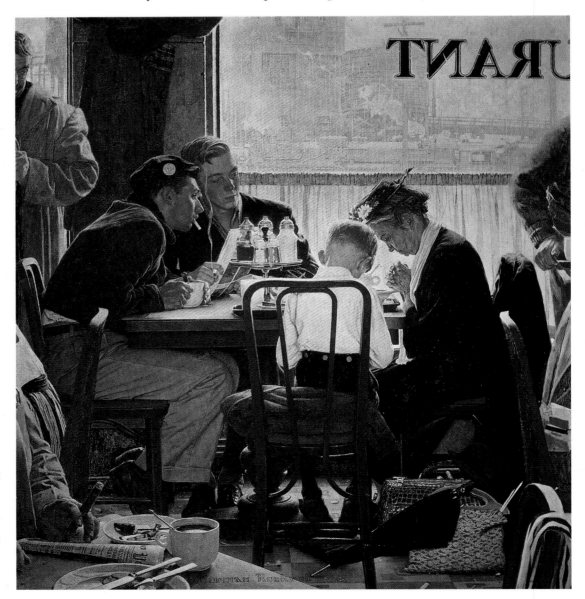

Right: *Readers of the* Post *voted* Saying Grace – *the November 24, 1951, cover – their favorite of all time. Although more properly a Thanksgiving painting, it has since become a Yuletide staple.*

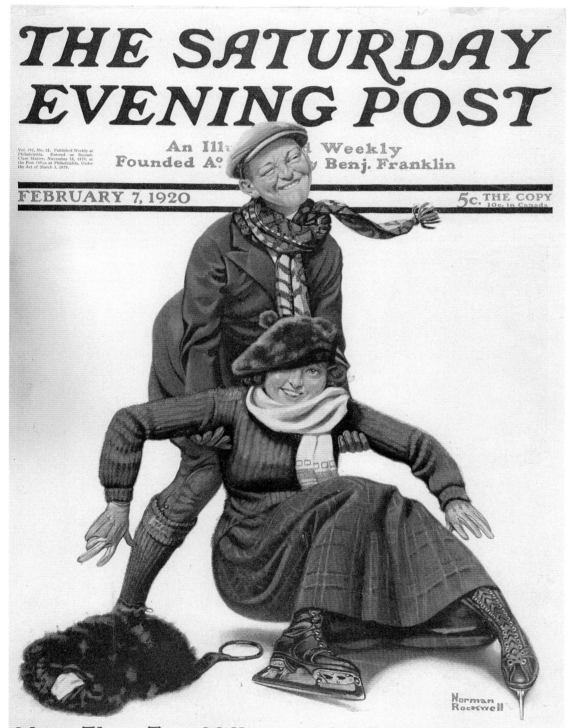

Left: *Even Rockwell's generic winter scenes, such as this February, 1920, Post cover, are commonly associated in most people's minds with his Christmas painting.*

heaven forbid, offense. Among such accepted themes were pretty girls and stylish women (both wholesome); patriotism (idealistic); holidays (warm and conventional); young love (tender, touchingly awkward); and sprightly childhood, golden old age or some combination of the two (affectionately treated, humorous and/or sentimental). There were a few other possibilities, but not many. Thus if cover artists were permitted to address their audiences directly, they were nevertheless compelled to do so in a painfully restricted vocabulary.

In 1916 Norman Rockwell still had a good deal to learn about draughtsmanship, color, composition and painterly technique, but because he had done so much work for youth magazines he was already something of an expert in ex-

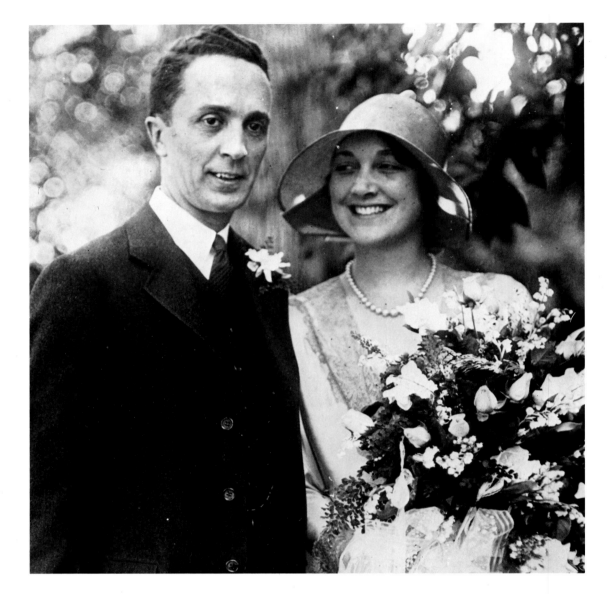

ploiting the possibilities of one cover theme, sprightly children, and he had begun to branch out into the youth-and-age and holiday themes as well. It was probably this, as much as the state of his developing artistic skills, that secured for him his final great professional breakthrough. To his surprise and delight, *The Saturday Evening Post*, then rapidly becoming the nation's premier adult mass-circulation magazine, accepted not one, but three of his proposals for covers. The first to appear, on May 20, 1916, shows two boys, evidently on their way to a sandlot base-ball game, teasing a third, whose parents have obliged him to take the family baby for a stroll in his carriage. Before the year was out the *Post* would publish five more Rockwell covers, all save one dealing with children or with youth-and-age. The exception was Rockwell's very first Christmas cover for the *Post*, a scene of a grand-fatherly man trying on a Santa Claus outfit in a costume shop.

Now that Rockwell had become a regular *Post* cover artist he had truly entered illustration's big time. His work might not yet have the Leyendeckers' high polish or the muscular vitality of Flagg or the dramatic power of Wyeth, but he was at least now of their company, and there was still plenty of time to improve. He was, after all, only 22.

He married Irene O'Connor, a schoolteacher from Potsdam, New York, that same year, and, after a brief stint in the Navy during World War I, Rockwell and his bride settled in New Rochelle, a fashionable New York suburb and then something of an artist's colony. He was now pouring forth magazine covers, mostly for

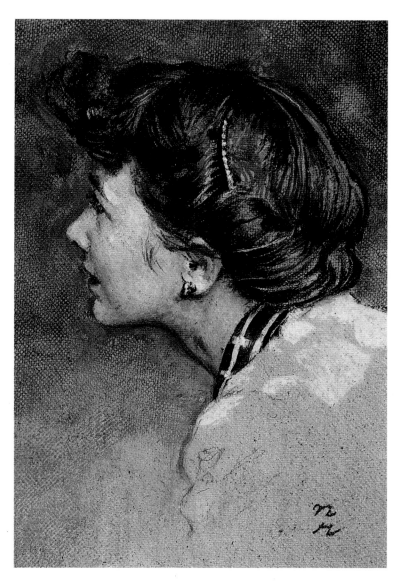

Left: *Rockwell married his second wife, Mary Barstow, in 1930. Mary was the mother of all three of Norman Rockwell's children: Jarvis, Tommy and Peter.*

Right: *It is not known precisely when, in the course of their 29-year marriage, Rockwell did this sensitive portrait of Mary Barstow Rockwell.*

the *Post* but also for *Colliers, Leslie's, Liberty,* the old *Life* and indeed virtually every important illustrated magazine in America. His technique improved astonishingly fast, and either because magazines were becoming more experimental or because Rockwell could wield more influence over his art directors, his range of themes expanded steadily. It was now not solely a matter of kids and grandpas: all sorts of vignettes (positive, to be sure) of daily middle-class American life began to appear on his canvases, as, increasingly, did excursions into history and fantasy.

His first marriage ended in divorce in 1929. Perhaps to some extent on the rebound, the following year he precipitately married Mary Barstow, another schoolteacher, whom he had met in California while on assignment there for the *Post.* It proved an excellent choice, for the couple lived happily together until Mary's death in 1959, raising a family of three boys in the interim.

In 1939 the Rockwells finally moved away from the New York area and settled in the small Vermont town of Arlington. Some writers have credited the down-to-earth influence of Arlington (a place where Rockwell no longer had to *imagine* what small-town life was like) with the significant changes that soon began to appear in his style. There may well have been other factors – the sobering experience of World War II, changing editorial formulae in the big magazines, simply his own internal evolution as an artist – but whatever the reason, Rockwell's work of the 1940s and 50s shows a striking advance over anything he had

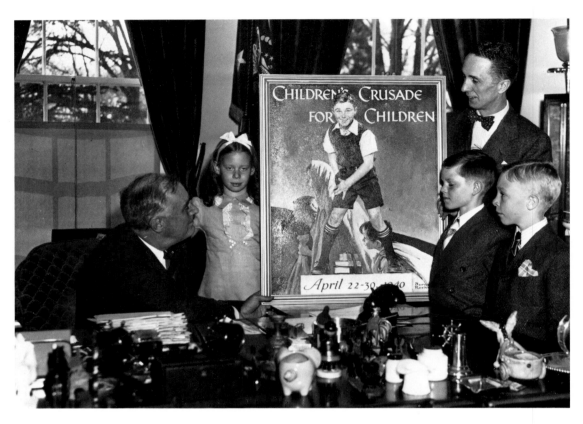

Right: *Rockwell painted this poster for a war relief drive in 1940 and here presents it to President Roosevelt. The boy on the far right is Jarvis Rockwell.*

done before. His technical proficiency was now truly amazing, beggering in its virtuosity the description "photographic realism" that critics have so often ignorantly applied to his work. At the same time, the anecdotal quality in many of his paintings became more subtle and thoughtful and their power became correspondingly greater.

In 1953 the Rockwells moved to another small town, Stockbridge, Massachusetts, and Rockwell stayed on there after his second wife's death. In 1961 he married a Massachusetts girl, Molly Punderson, yet another former teacher, and the couple would remain in Stockbridge until Rockwell's death in 1978.

During the 1960s and 70s Rockwell's work continued to exhibit the same high standards he had attained in the 40s and 50s, and in some cases, largely because of the new kinds of assignments he was being given, his paintings reached new heights. But professionally, the last two decades of Rockwell's life were not altogether happy. In the new age of television the day of the big illustrated magazines was entering its twilight. Frantically, and with uniform lack of success, the big magazines tried to combat plunging circulations with incessant changes of editorial formulae. Everything that was old, that had worked in the past, became hostage to this desperate process. And so it was that in 1963 *The Saturday Evening Post*, after nearly half a century, told Rockwell that his services would no longer be needed. It was a cruel blow to him emotionally, though in fact he did not need the money and soon received numerous commissions from other sources. Some of his best-remembered works date from this post-*Post* period – especially such semi-reportorial canvases as *The Problem We All Live With* and *New Kids in the Neighborhood* that he painted for *Look*.

But though his artistic powers had never been greater than at this period, his critical reputation was on the wane. Throughout his career he, like all his illustrator colleagues, had been disparaged by so-called "serious" artists for his unswerving devotion to accessibility and the popular taste, but at worst, such cavils had been confined to aesthetic debate. In the socially rebellious 1960s, when so many aspects of American life that had formerly been supposed non-controversial

suddenly became "politicized," Rockwell found himself the target of a new kind of criticism. Activists and rebels, many of them too young to have had any personal recollection of 80 percent of the period in which Rockwell had been painting about American life, branded his work as emblematic of the "establishmentarian" vices then under attack and denounced it as bourgeois, complacent, insensitive, indifferent to burning social and moral issues and much else. Thus Rockwell's lifelong avoidance of the controversial in his work became itself controversial.

How fair this "he-who-is-not-with-me-is-my-enemy" form of reasoning may have been, or whether it was a valid criterion for making aesthetic judgements, is no doubt debatable, but it undoubtedly damaged Rockwell's standing in some influential circles and can have done little for his always-fragile self-confidence. Yet like many things that happened in the 1960s and 70s, there was more appearance than reality in the decline of Rockwell's reputation. His basic middle-American audience never seriously wavered in its admiration and affection for him, and the resurgence of interest in his work since his death has been little short of phenomenal. It may still be too early to say precisely where, in the pantheon of American art, history will place Norman Rockwell, but that he will be there somewhere is now certain. How sad that he did not live long enough to share in that certainty.

In looking at Rockwell's Christmas paintings we can infer a fair amount about both his own artistic development and how it interacted with popular taste. As we might expect, his pre-*Post* covers and advertisement work featured mostly children or youth-and-age scenes, though his first *Post* Christmas cover (December 9, 1916) was one of his few paintings of this period in which a child did *not* appear. While he continued to do Christmas covers for many other magazines, he did not do another for the *Post* until 1919. That was the real begin-

Left: Rockwell moved away from the New York City area in 1939 and always thereafter lived in small rural towns. In this picture he is crossing a field near West Arlington, Vermont, with a pair of his dogs.

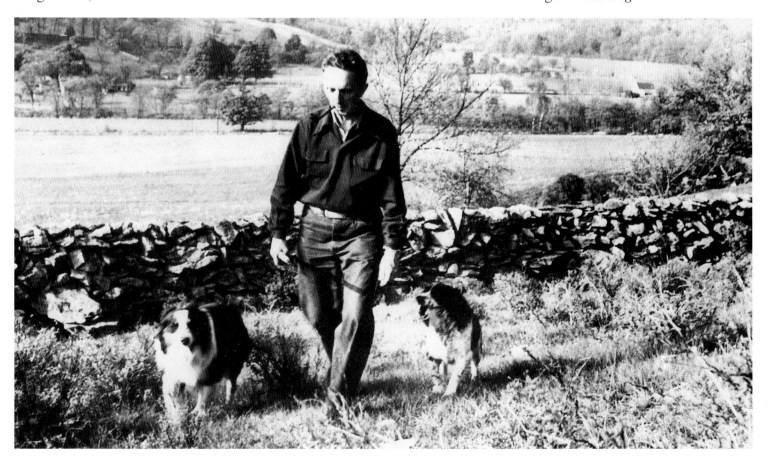

ning of the tradition, for he would do the *Post*'s Christmas cover every year thereafter until 1943.

The 1919 cover was a youth-and-age scene, but this standard theme would not again appear on a *Post* Christmas cover for another 14 years. Throughout the whole decade of the 1920s Rockwell would use only two subjects for *Post* covers – Santa Claus or a Dickensian Christmas (five of each). His technique would improve impressively during these years, but the near invariability of his subject-matter did much to establish the traditional quality of his annual offering to the American people: his covers were like familiar Christmas cards, instantly identifiable as coming from an old friend.

Somewhat more experimental in the 1930s, he introduced several new themes to his *Post* Christmas covers during the decade, but none that had not previously appeared elsewhere in his non-Christmas paintings. The big change came – as it did in his work as a whole – in the 1940s. The 1940 cover – of a bewildered boy on a subway train looking at a Santa Claus beard protruding from the pocket of a dozing passenger – came close to breaking a *Post* taboo about suggesting to children that Santa might not exist. The 1941 cover was even more surprising: a lovely scene of a newspaper kiosk on a snowy evening, it made use of no standard theme, had almost no anecdotal content and contained no overt reference to Christmas. It is nevertheless one of his best-remembered covers.

He did one last conventional Santa for the *Post* in 1942, but no December cover in 1943. When he came back in 1944 with his next Christmas cover it was another surprise. It is a scene of rush-hour in Chicago's North Western Station on a mid-December evening. Although the painting is full of allusions to Christmas (people carrying packages, servicemen returning home on leave and so on), its message is muted, slightly detached, non-traditional and only remotely anecdotal.

Again, he did not produce Christmas covers in 1945 or 1946, and the 1947 cover was, strictly speaking, a post-Christmas one. His last Christmas cover for *The Saturday Evening Post* appeared on December 25, 1948, and it is hauntingly inexplicit. It shows a large group of family and friends (among them Rockwell)

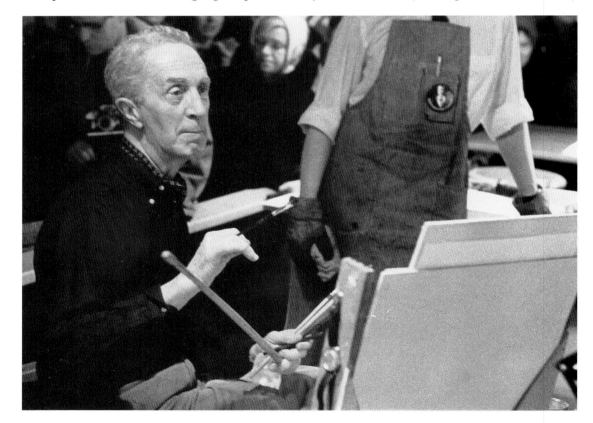

Right: *Rockwell gives a demonstration of his technique to a Russian audience at an American Graphic Arts Exhibition held in Moscow in 1964.*

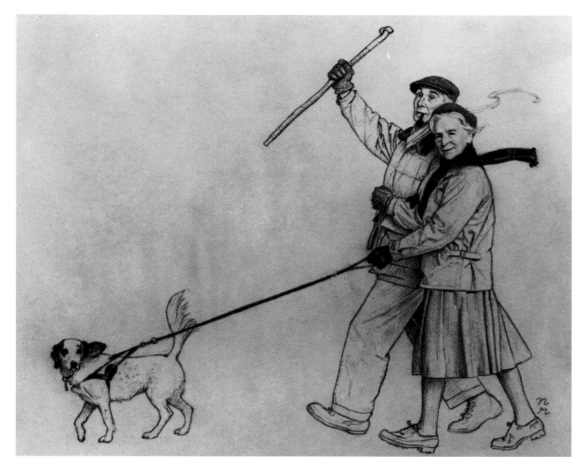

Left: *On this personal Christmas card designed by Rockwell he is shown walking with his third wife, Molly Punderson Rockwell.*

joyously welcoming home a returned man. Is he returning from the war? Probably, but nothing in the painting actually says so. We cannot even tell his age, since his face is turned away. And only the gift-wrapped packages under his arm and a faint hint of tinsel in the background suggest that all this may be taking place around Christmastime. On this reticent, almost ambiguous note Rockwell's long reign as American's foremost Christmas cover artist ended.

The end of the Christmas covers did not, of course, mean the end of his Christmas painting. His immensely popular work for Hallmark and Brown and Bigelow, mentioned earlier, went on for years recapitulating many of his old themes and approaches. But the more finished interior illustrations that he did for other magazines after his dissociation from the *Post* in 1963 probably better reflected the more mature and contemplative attitude towards the subject of Christmas that he had been developing since the 1940s. Two such pictures are particularly memorable. One is a handsome landscape mural (one of his very few) that he did for *McCall's* in 1967, showing the main street of Stockbridge at Christmastime. The other, done for *Look* in 1970, is called *Christmas in Bethlehem*. From a darkened rooftop a family of American tourists, a lone Arab and a group of armed Israeli soldiers on anti-terrorist patrol gaze down on a religious procession in the lighted square below. It is a simple, thought-provoking and powerful scene.

It is also one of the few Rockwell Christmas scenes (perhaps the only one) that contains any explicit reference to religion. It was hardly that Rockwell was himself irreligious, but his feeling for Christmas ran so deep that he could not bear to taint his pictures of it with any hint of sectarianism. It was the human dimension he loved best about Christmas (and, indeed, about all things), and if Christmas stood for a time of warmth, love, kindness and peace, these were gifts that Norman Rockwell, of all men, would never have withheld from any fellow human being for any reason.

THE PLATES

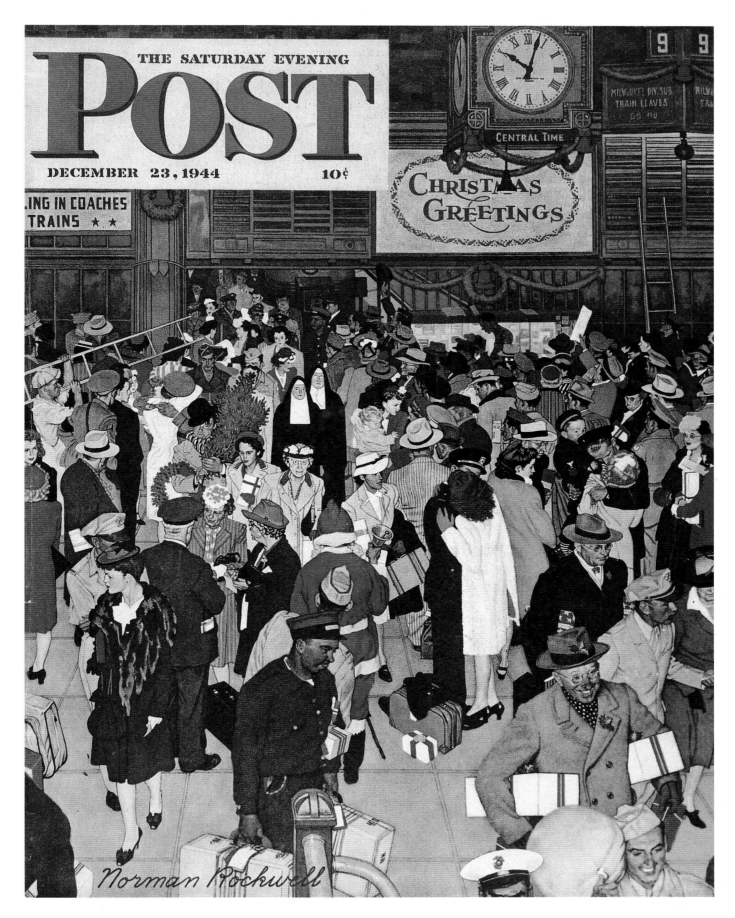

North Western Station, Chicago.
Post *cover, December 23, 1944.*

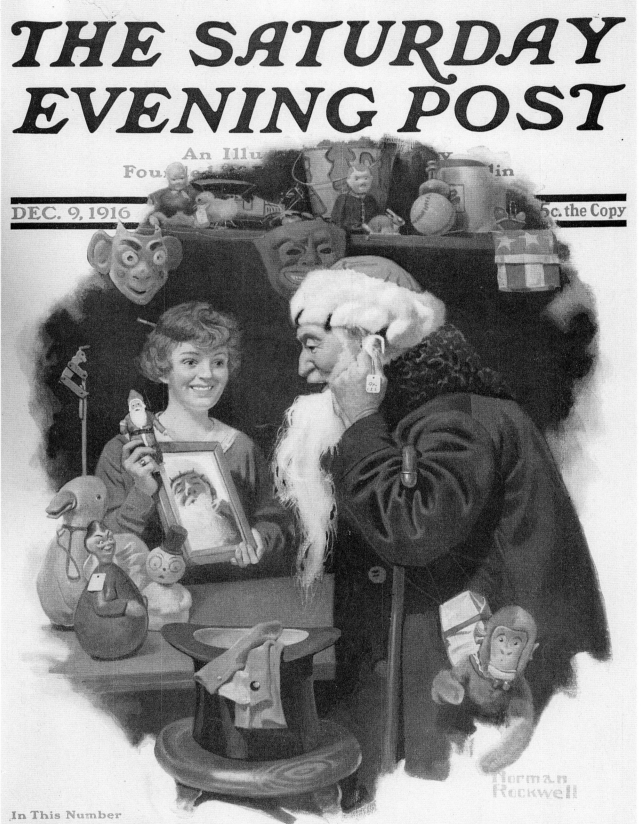

Playing Santa.
Post *cover, December 9, 1916.*

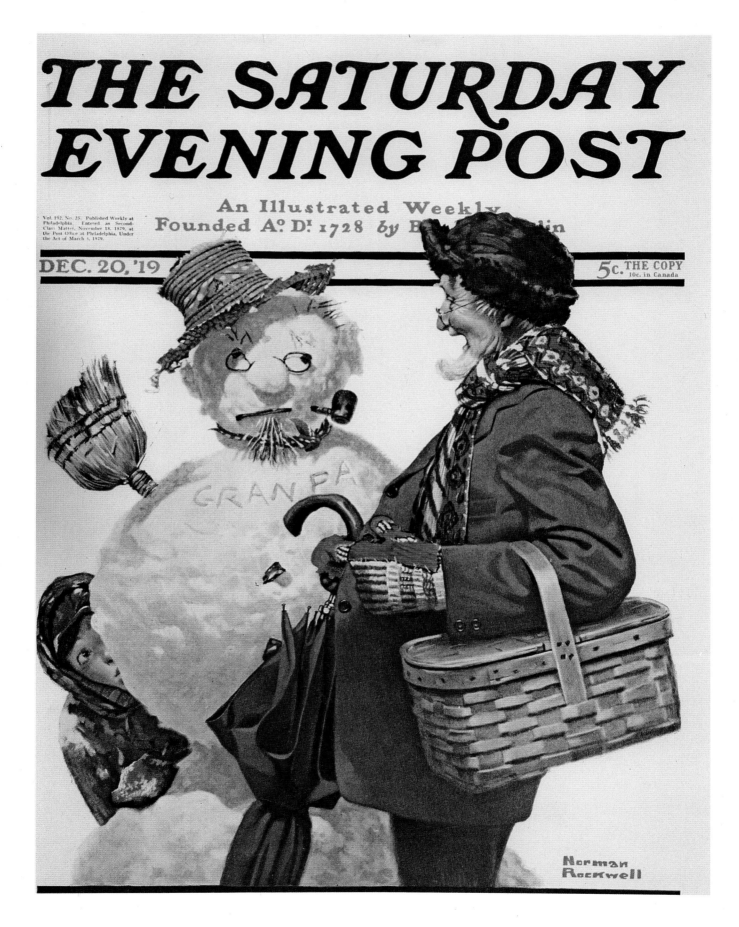

Gramps Encounters – Gramps?
Post *cover, December 20, 1919.*

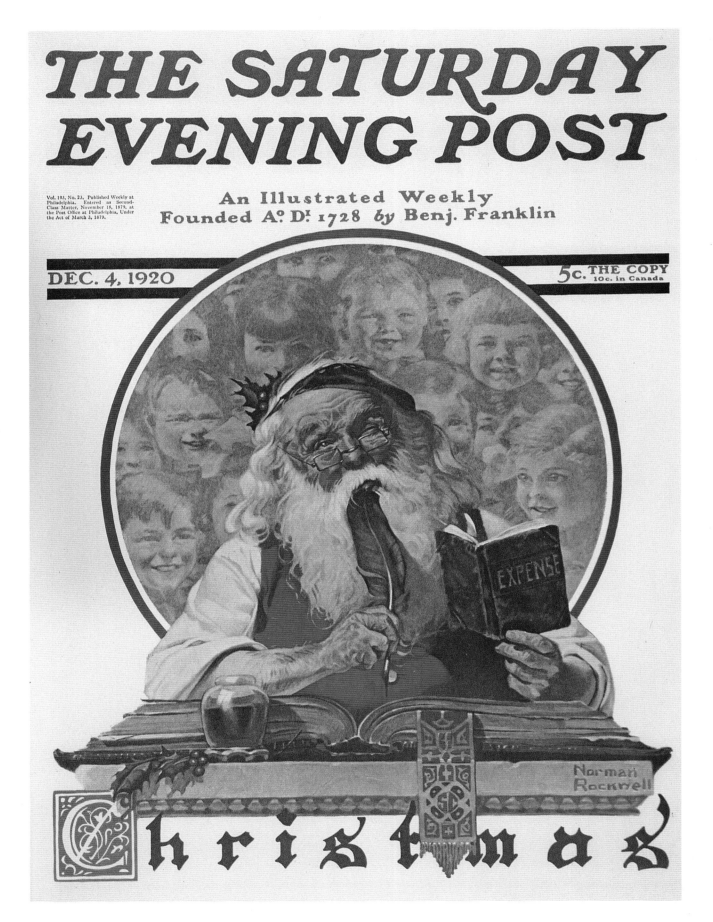

Christmas, 1920.
Post *cover, December 4, 1920.*

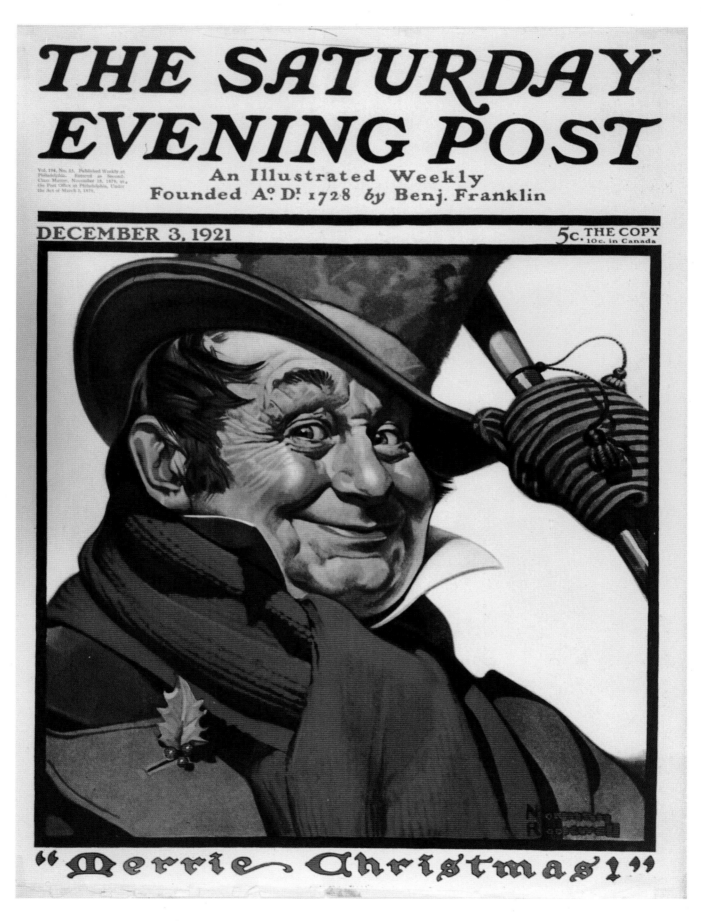

Merrie Christmas, 1921.
Post *cover, December 3, 1921.*

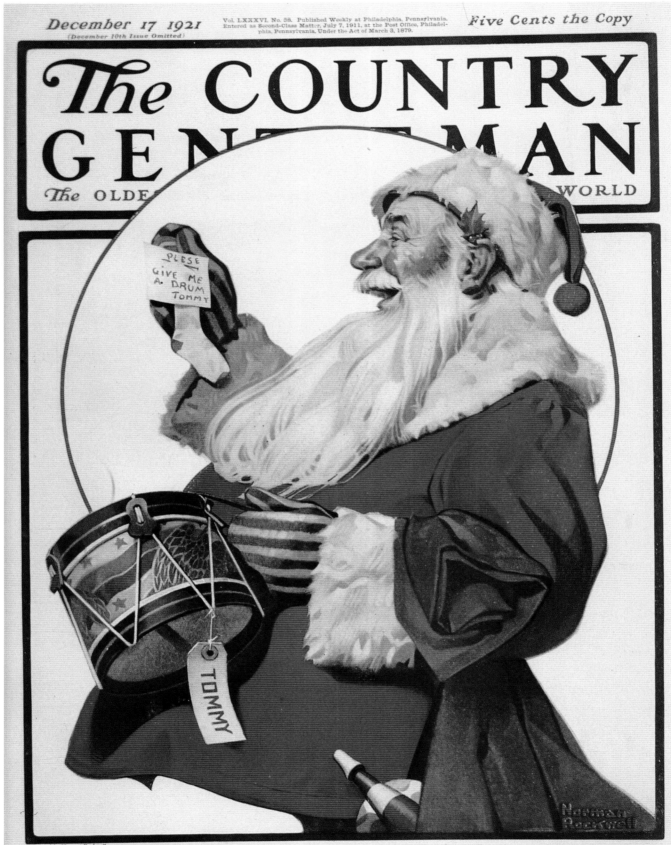

Santa with Drum.
Country Gentleman *cover, December 17, 1921.*

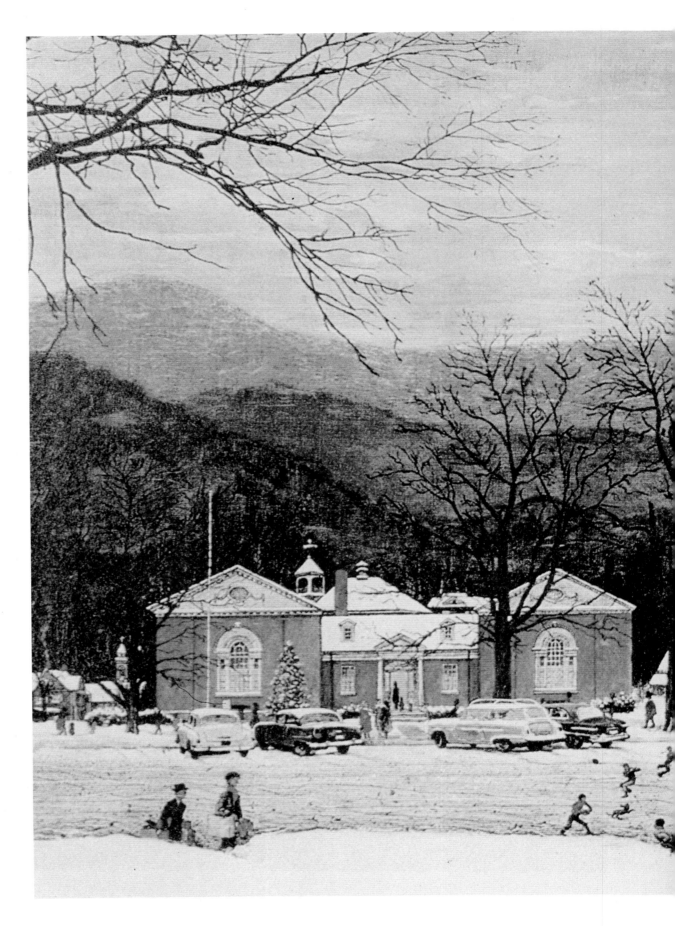

Stockbridge at Christmas.
McCall's *illustration, December, 1967.*

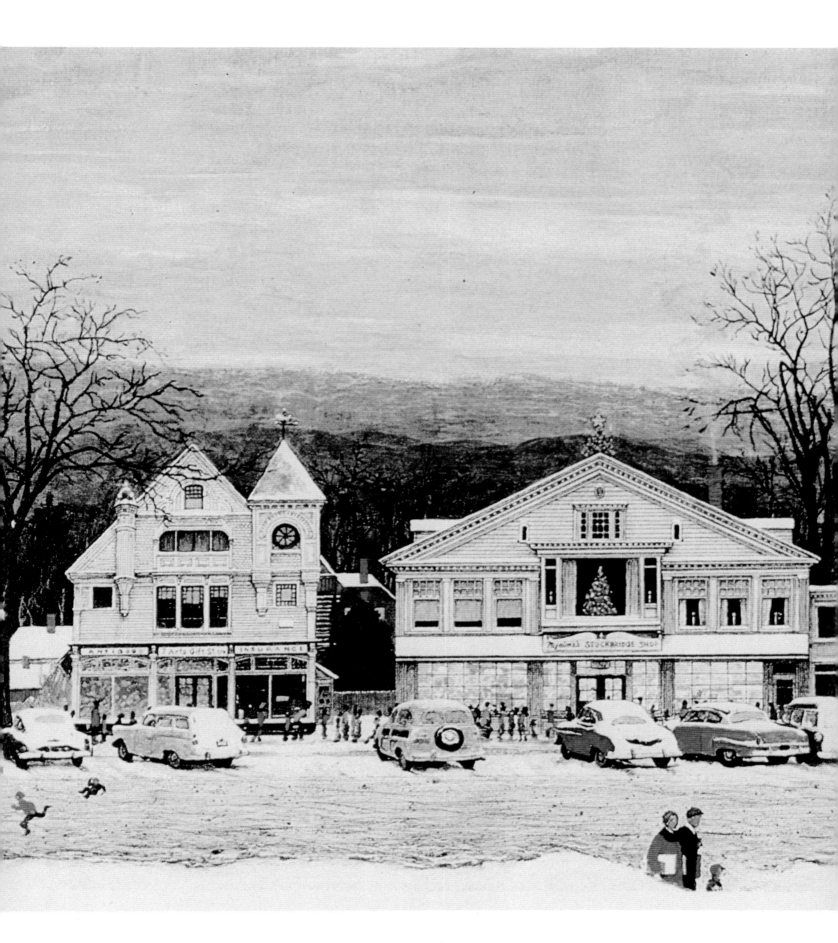

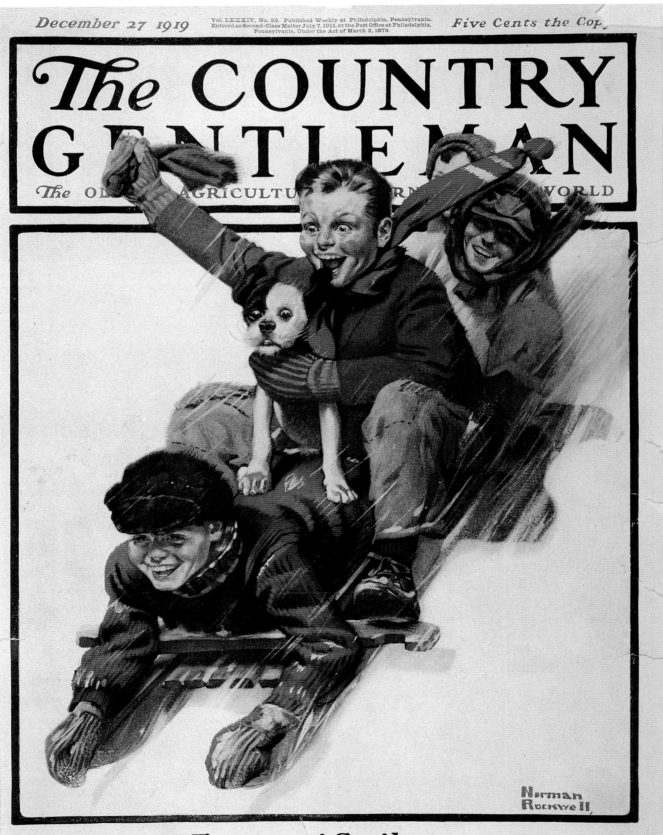

Downhill Daring.
Country Gentleman *cover, December 27, 1919.*

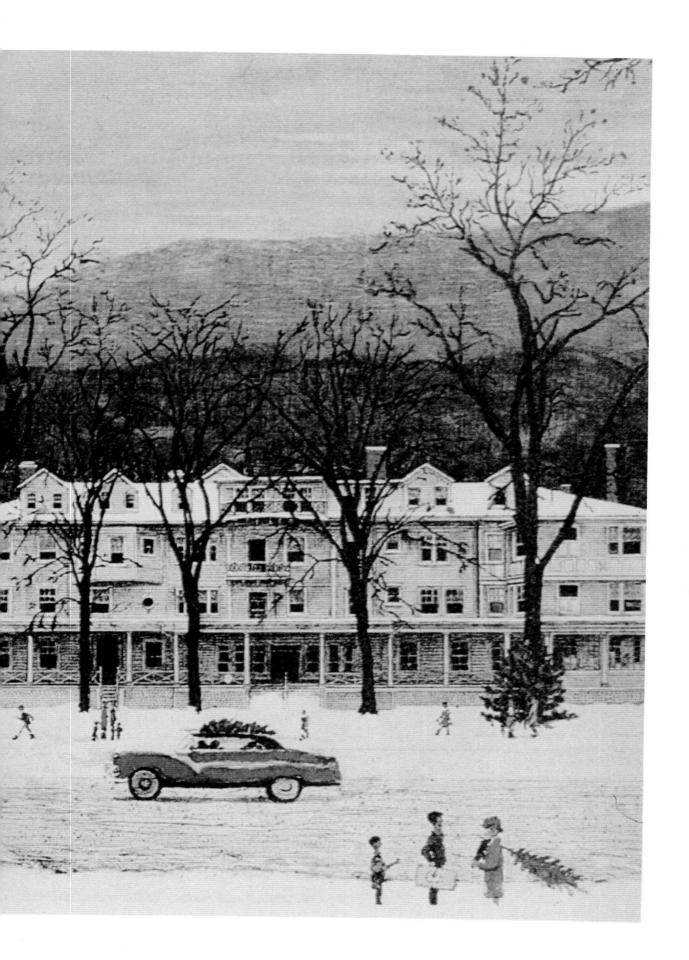

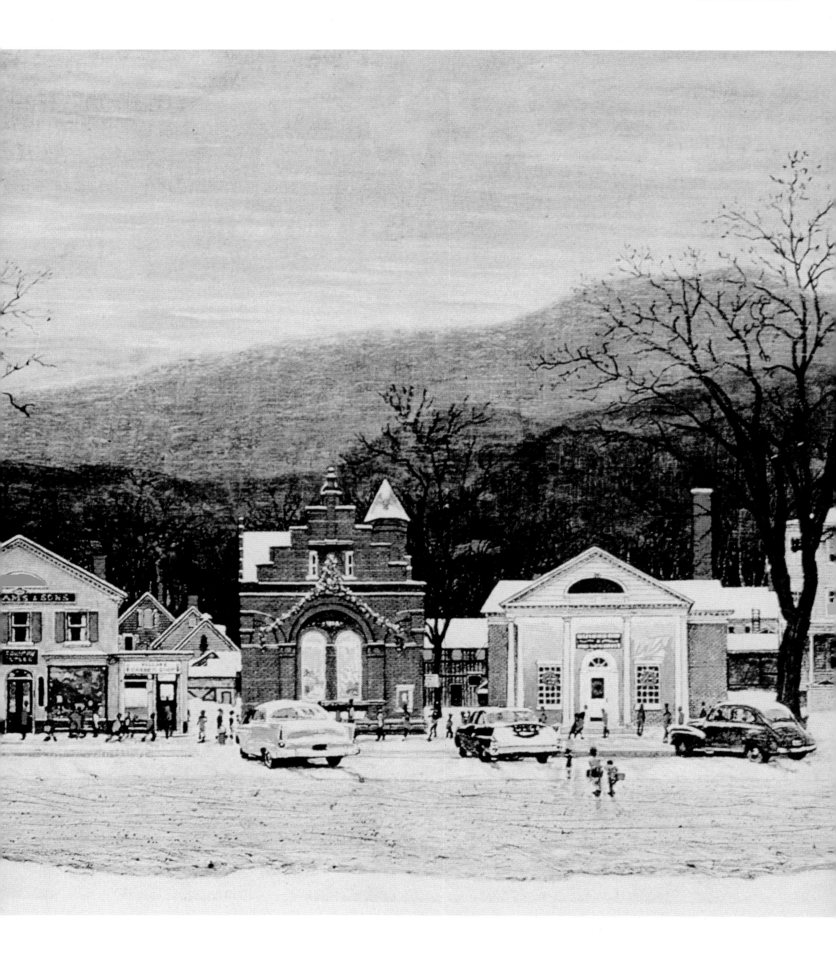

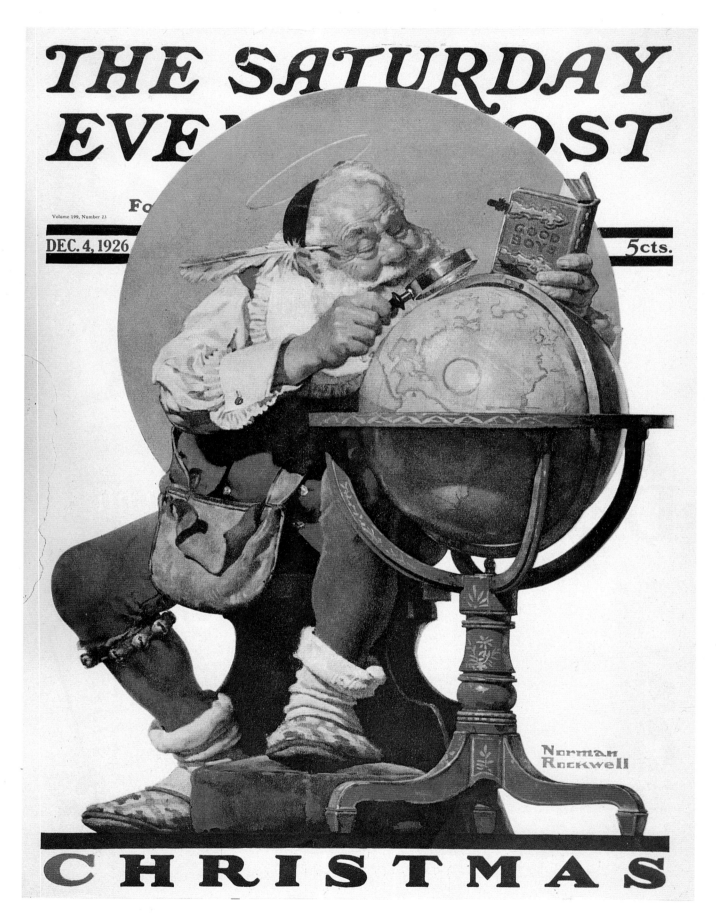

Christmas, 1926.
Post *cover, December 4, 1926.*

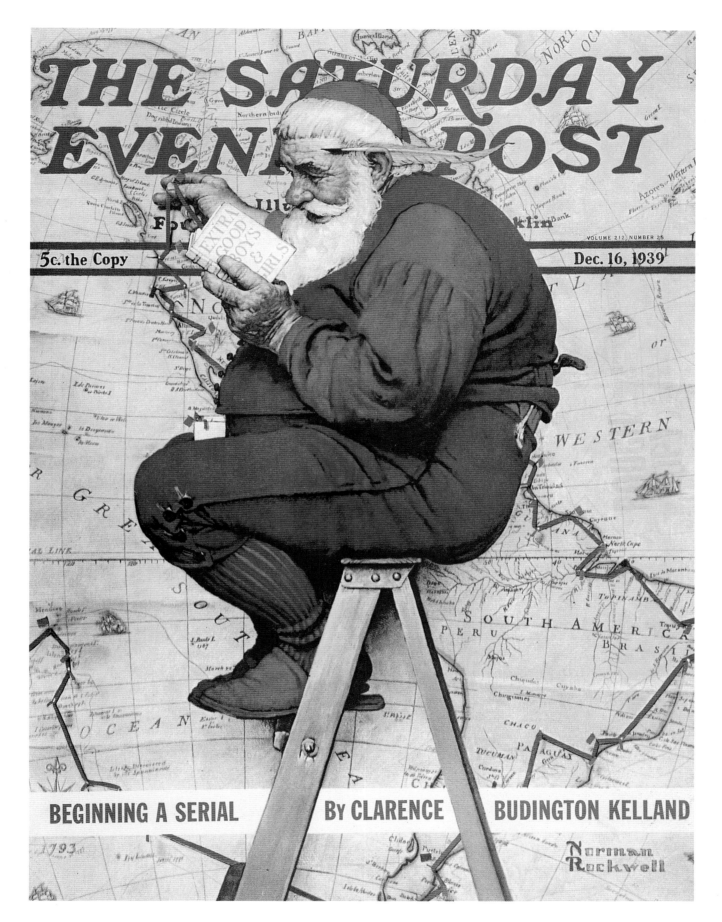

Extra Good Boys and Girls.
Post *cover, December 16, 1939.*

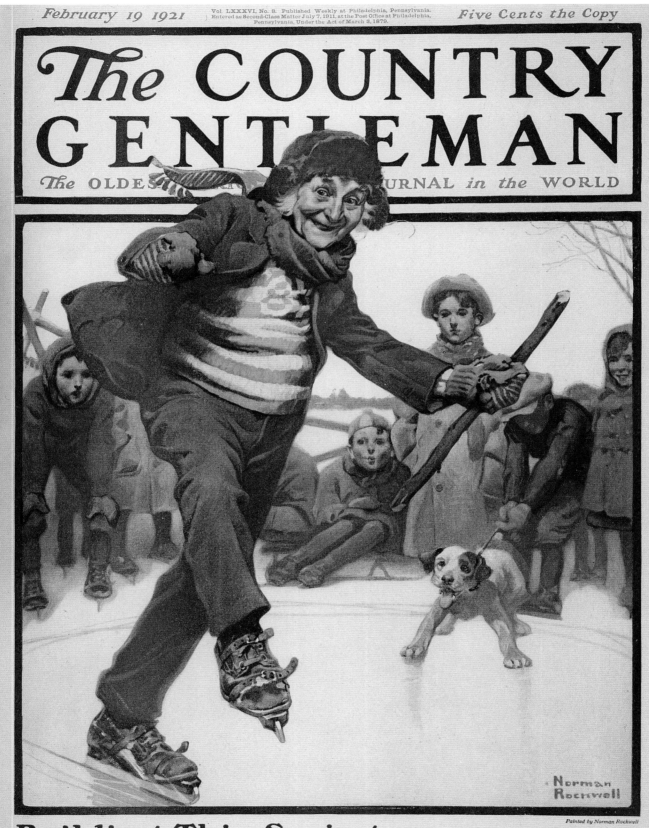

Gramps on Ice.
Country Gentleman *cover, February 19, 1921.*

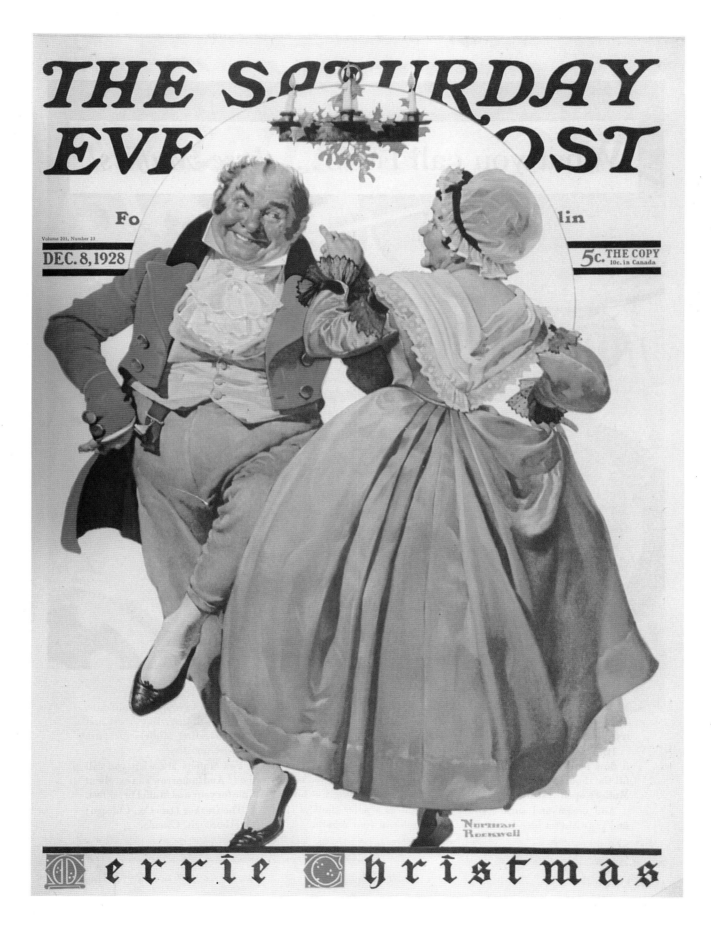

Merrie Christmas, 1928.
Post *cover, December 8, 1928.*

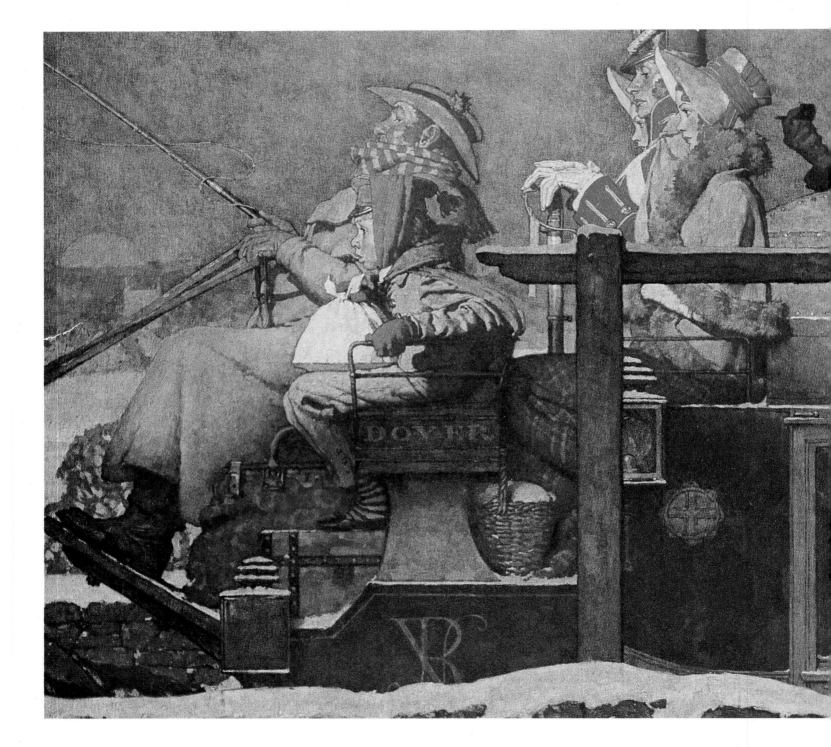

Dover Coach.
Post *illustration, December 28, 1935.*

45

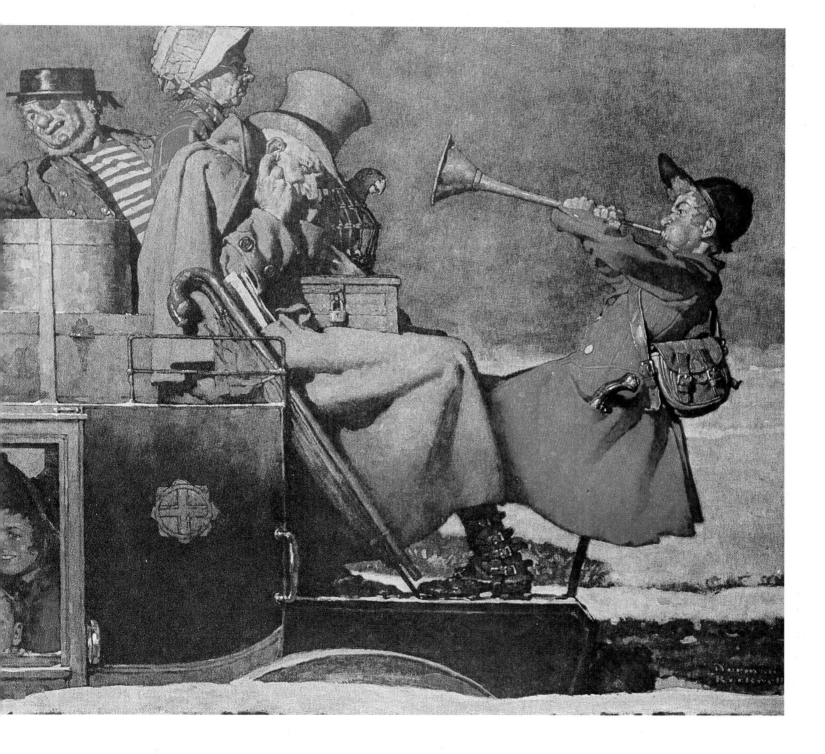

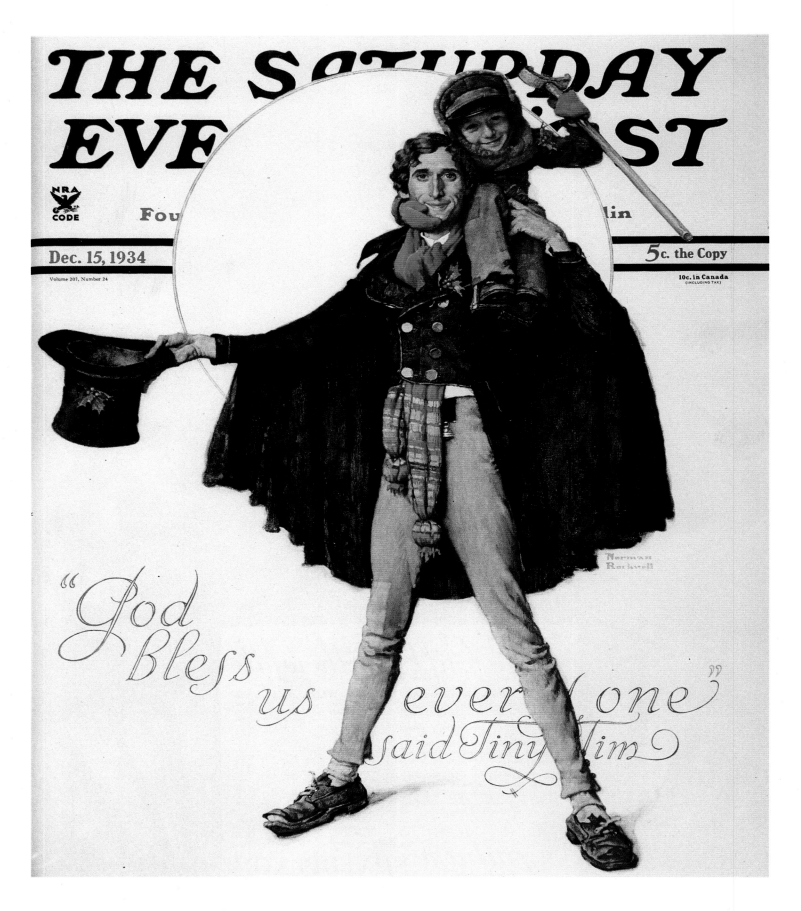

Tiny Tim and Bob Cratchit.
Post *cover, December 15, 1934.*

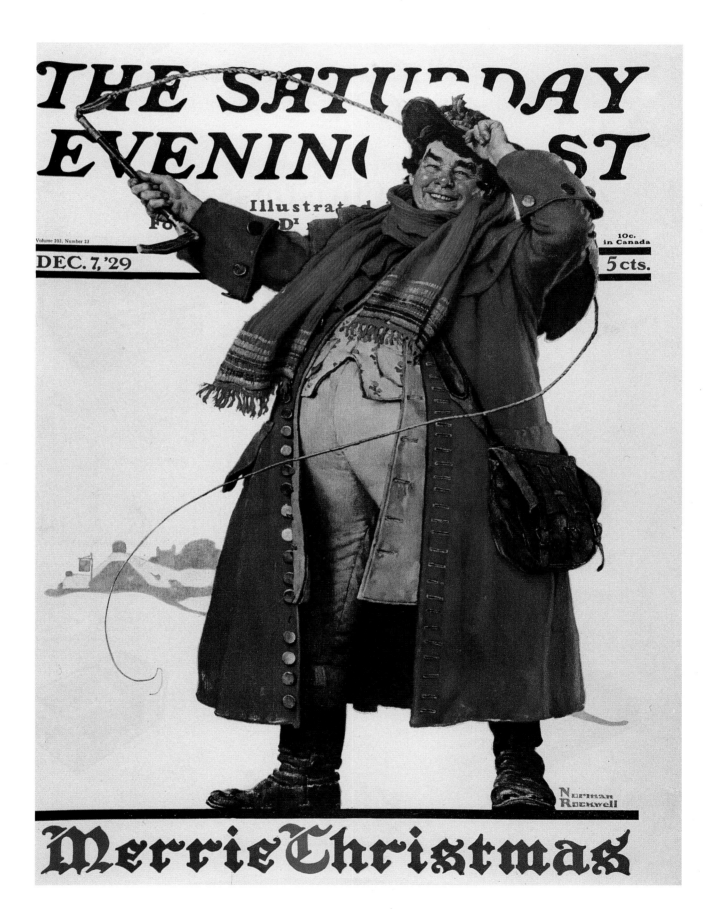

Merrie Christmas, 1929.
Post *cover, December 7, 1929.*

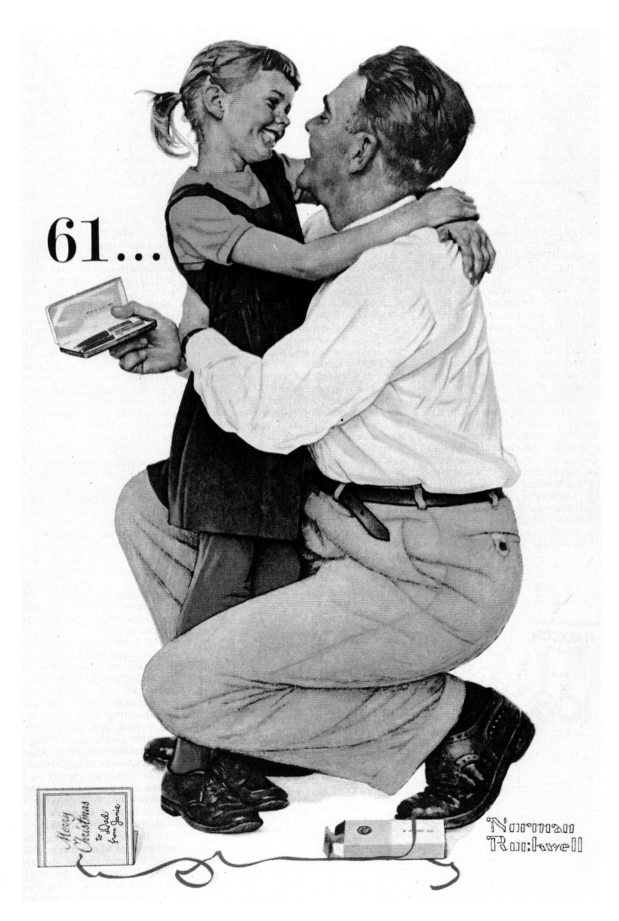

Dad and Daughter with Gift.
Parker pen ad illustration, November 28, 1959.

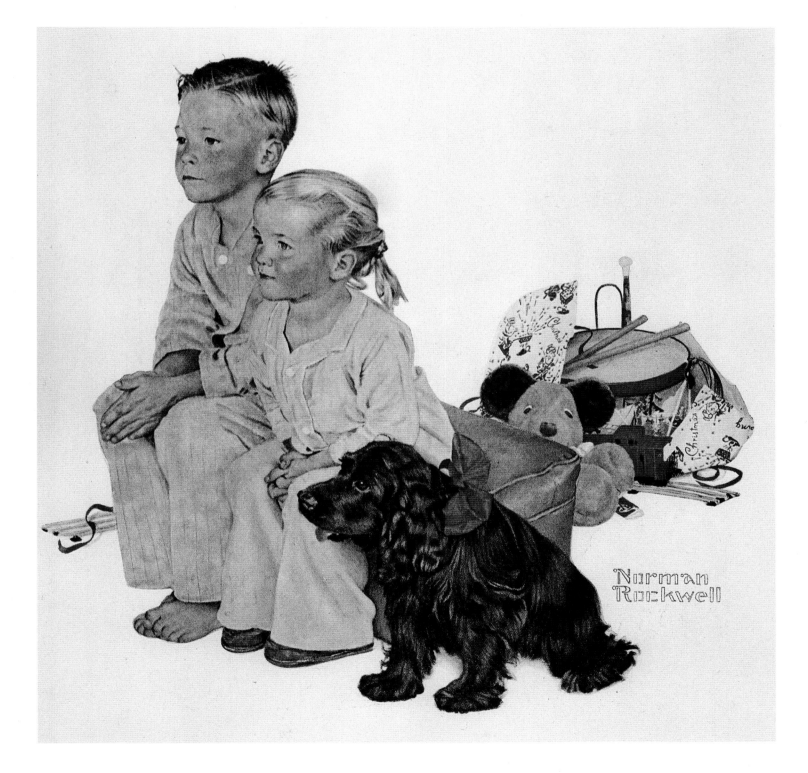

Boy and Girl with Dog and Toys.
Post *illustration, December 9, 1950.*

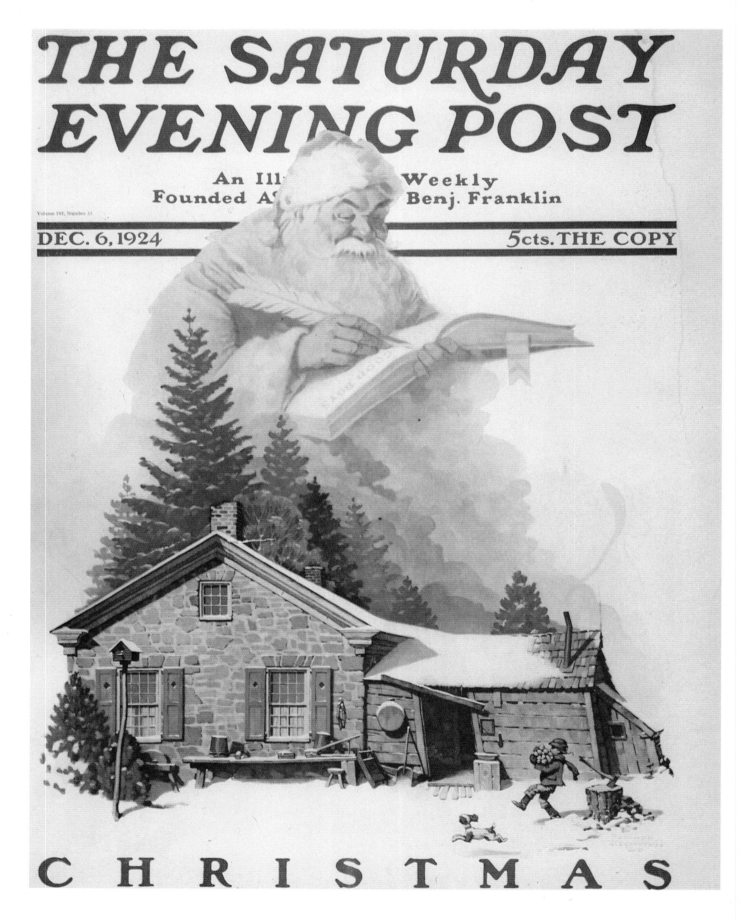

Christmas, 1924.
Post *cover, December 6, 1924.*

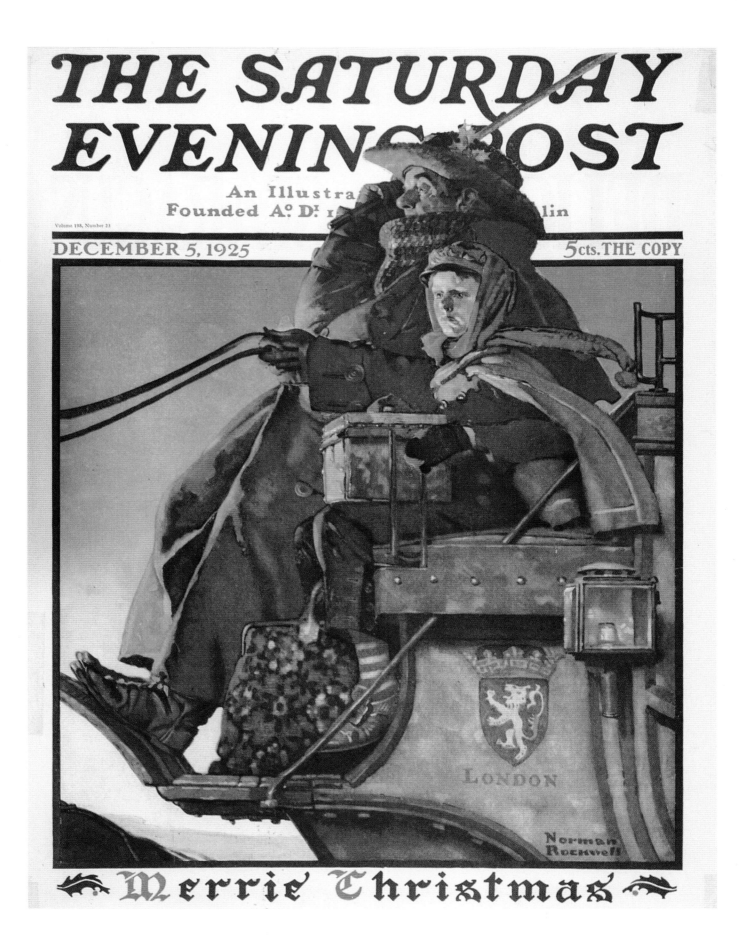

Merrie Christmas, 1925.
Post *cover, December 5, 1925.*

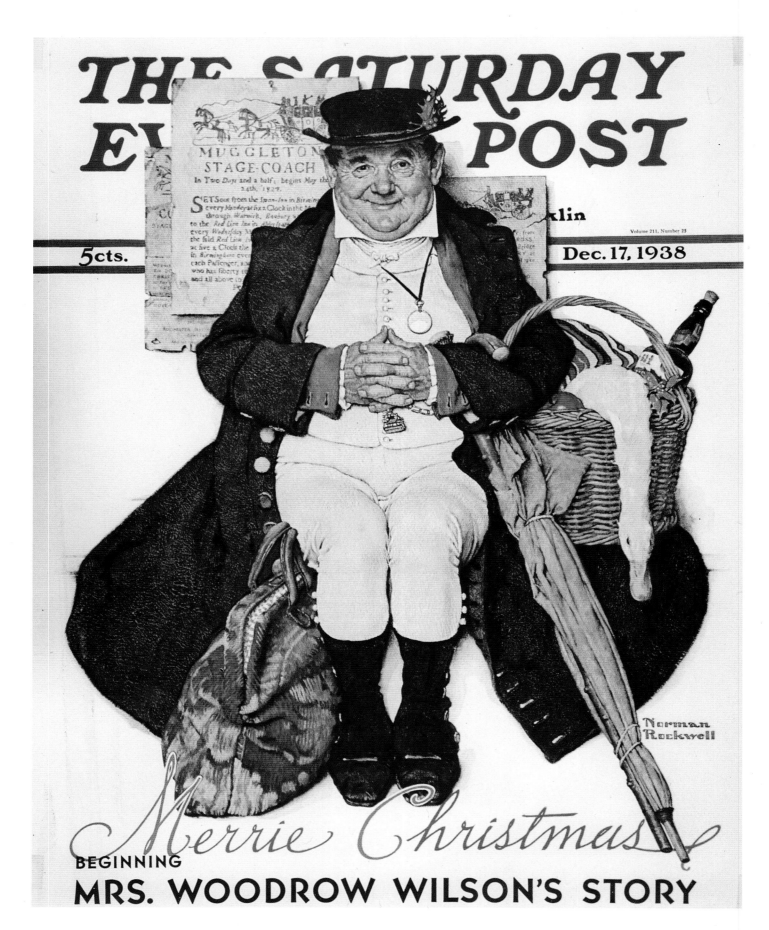

Merrie Christmas, 1938.
Post *cover, December 17, 1938.*

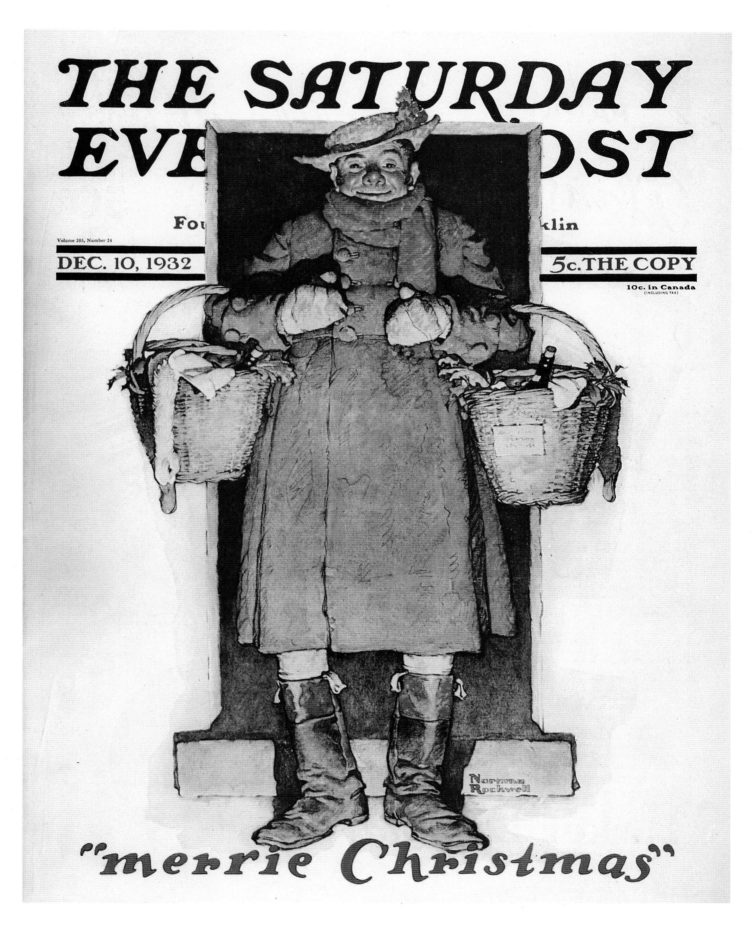

Merrie Christmas, 1932.
Post *cover, December 10, 1932.*

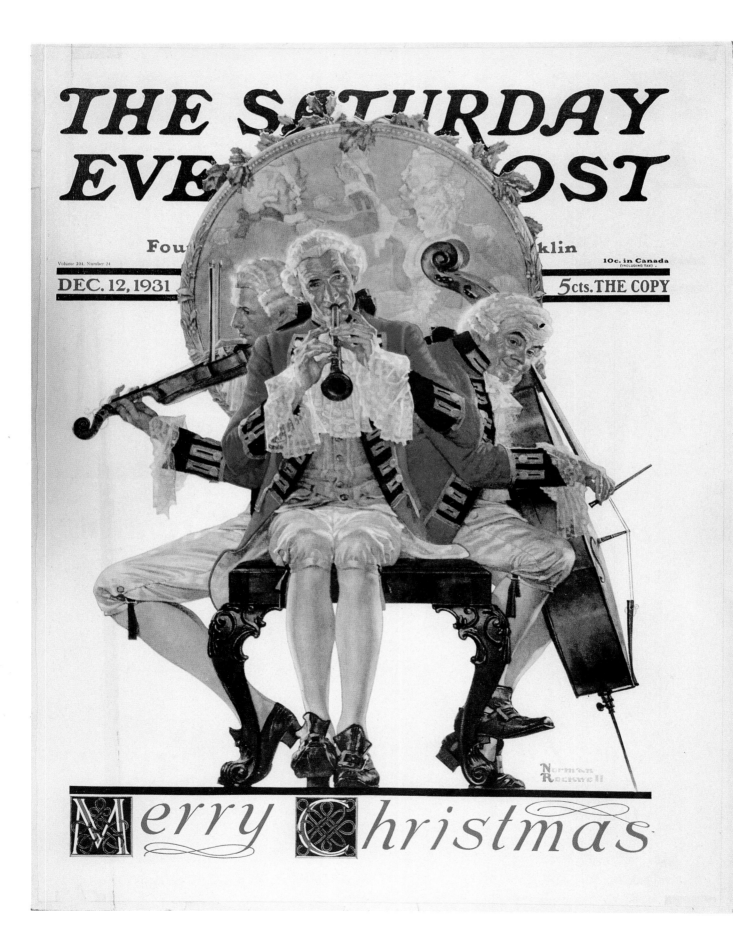

Merry Christmas, 1931.
Post *cover, December 12, 1931.*

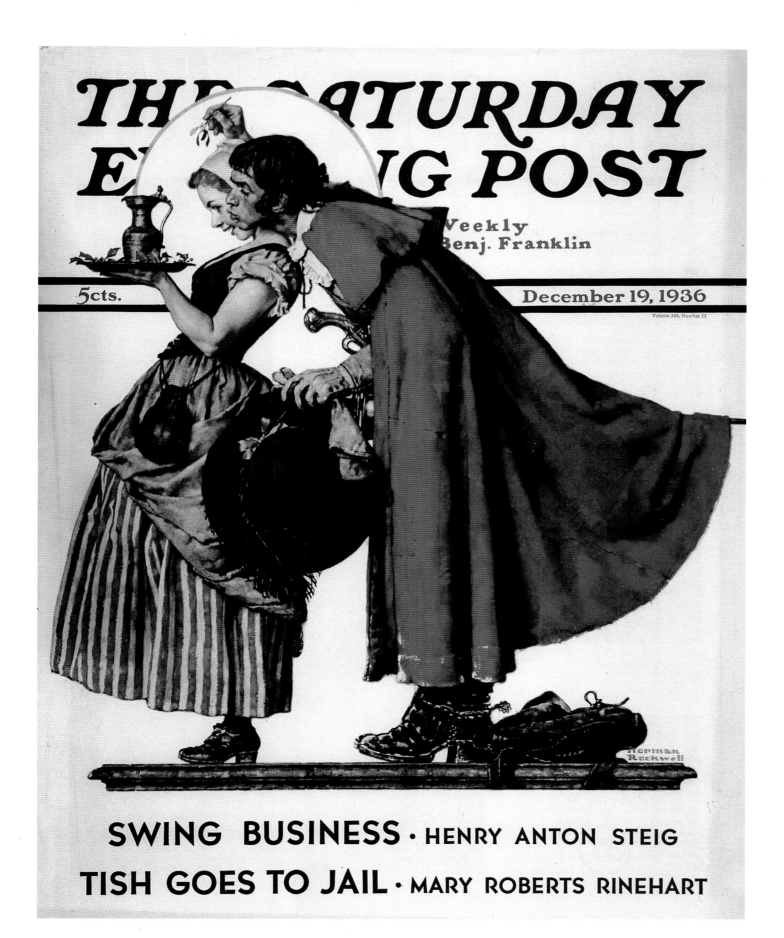

A Kiss Under the Mistletoe.
Post *cover, December 19, 1936.*

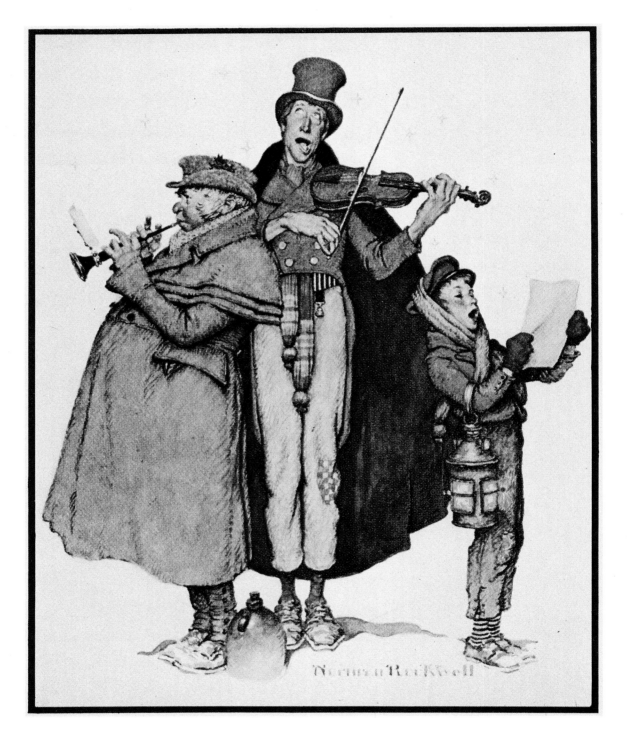

Christmas Song.
Hallmark card illustration.

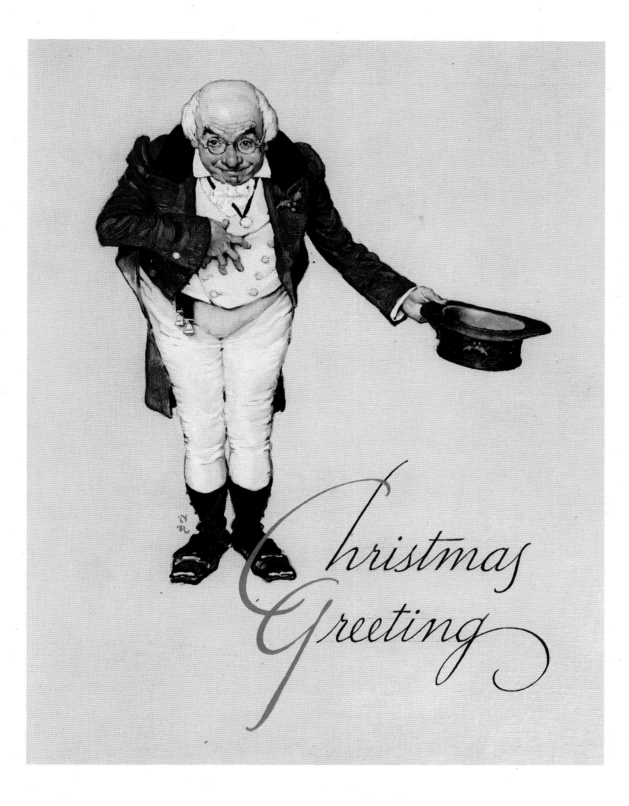

Christmas Greeting.
Hallmark card illustration.

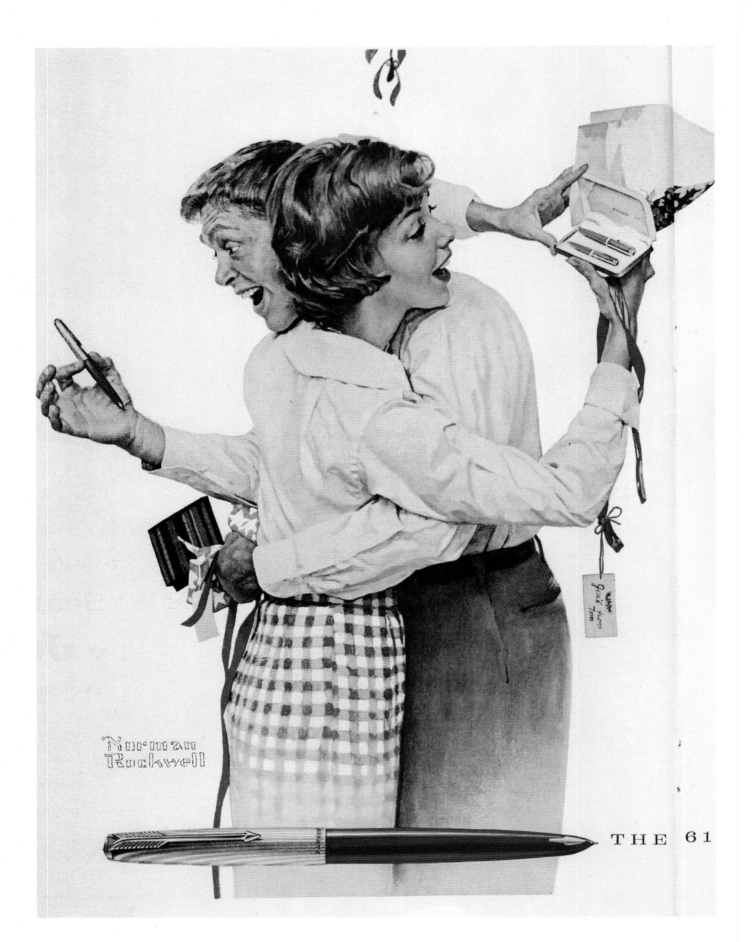

Pens at Christmas.
Parker pen ad illustration, December 5, 1959.

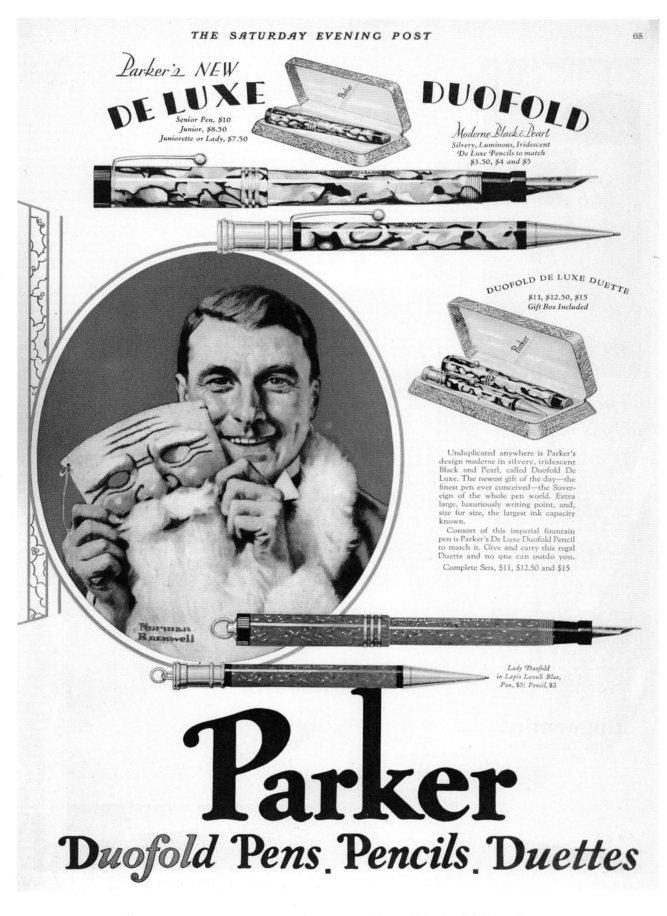

Santa Mask with Beard.
Parker pen ad illustration, December 1, 1928.

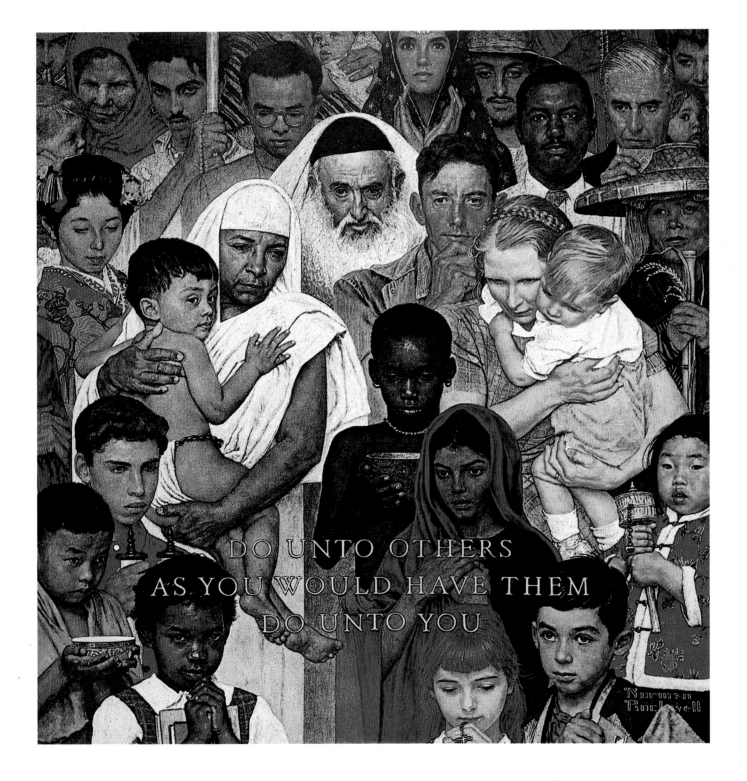

The Golden Rule
Post *cover, April 1, 1961*

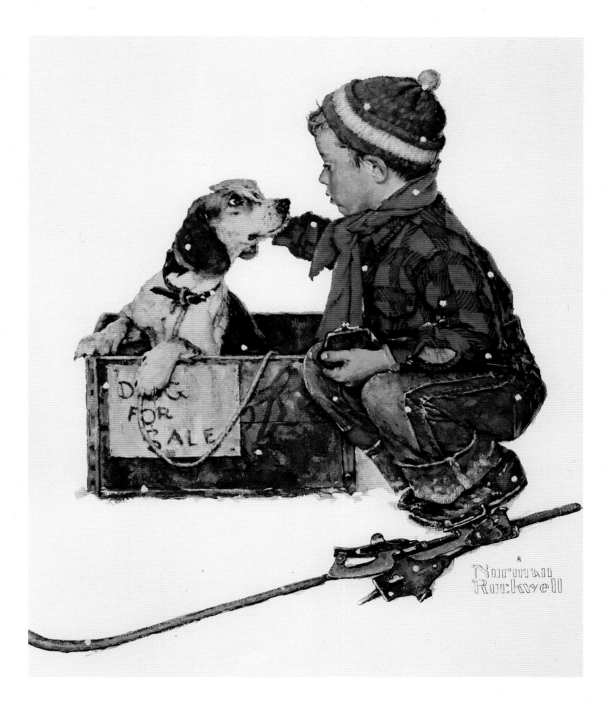

Boy and Dog.
Four Seasons calendar, 1958.

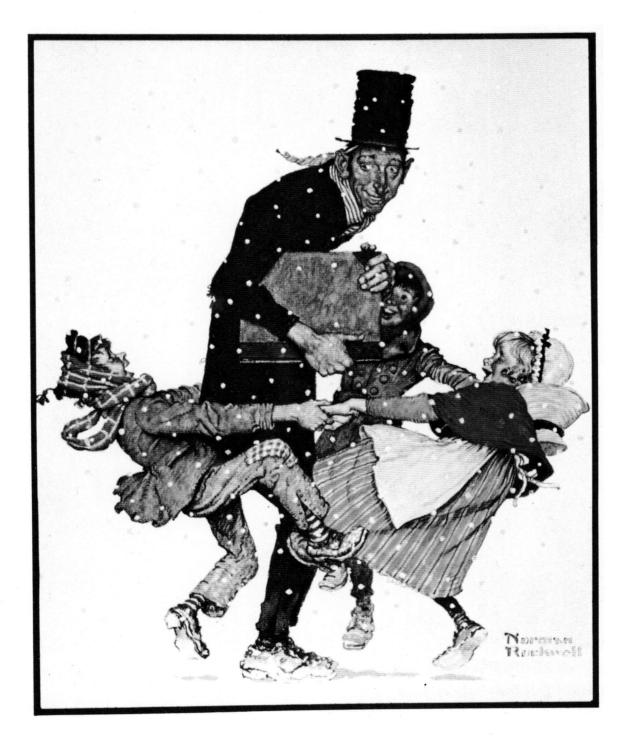

Bob Cratchit with Children.
Hallmark card illustration.

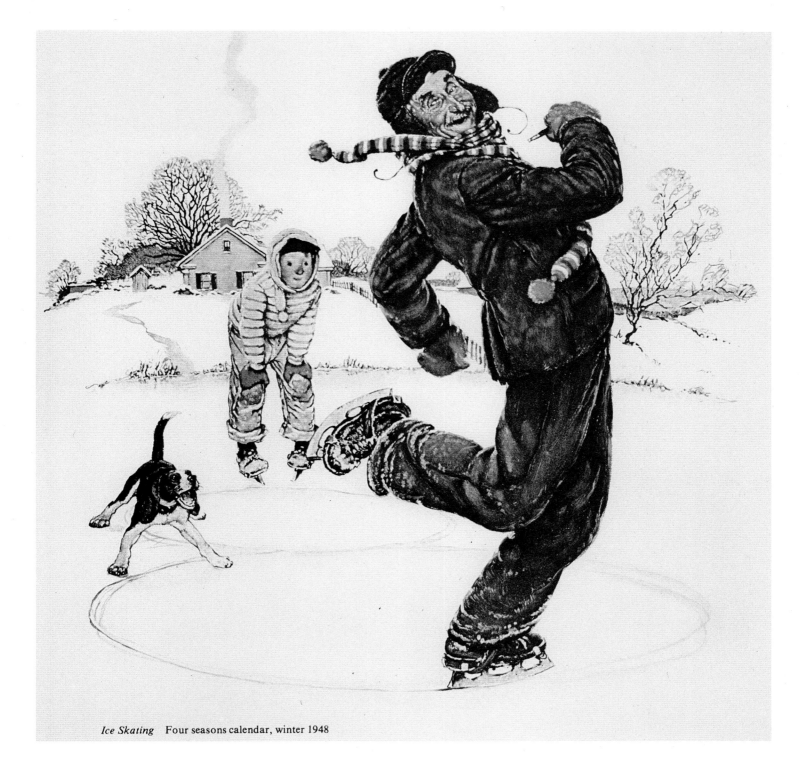

Ice Skating Four seasons calendar, winter 1948

Ice Skating.
Four Seasons calendar, 1948.

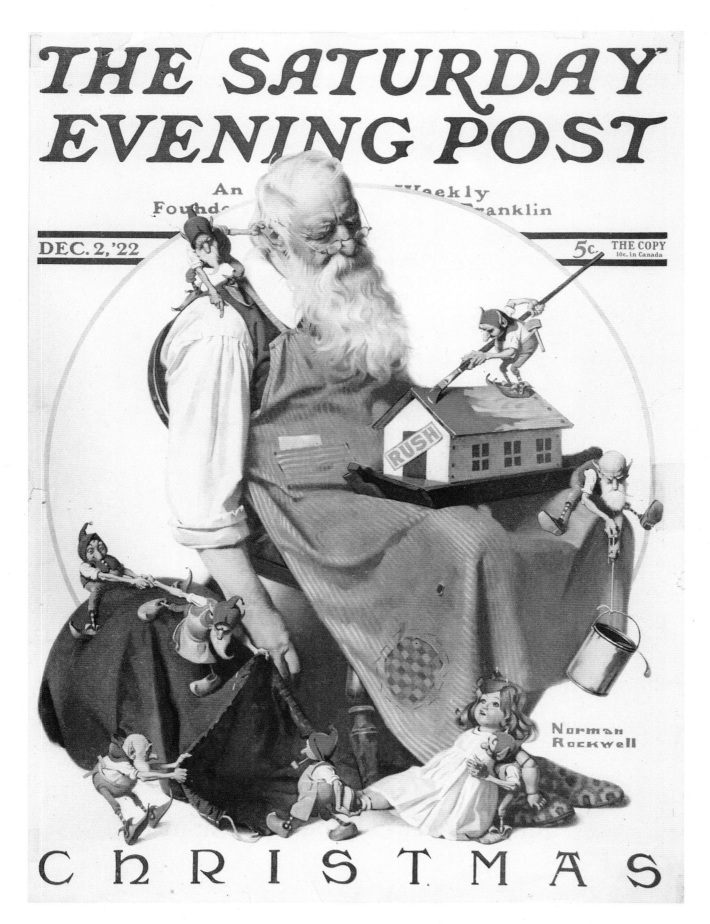

Christmas, 1922.
Post *cover, December 2, 1922.*

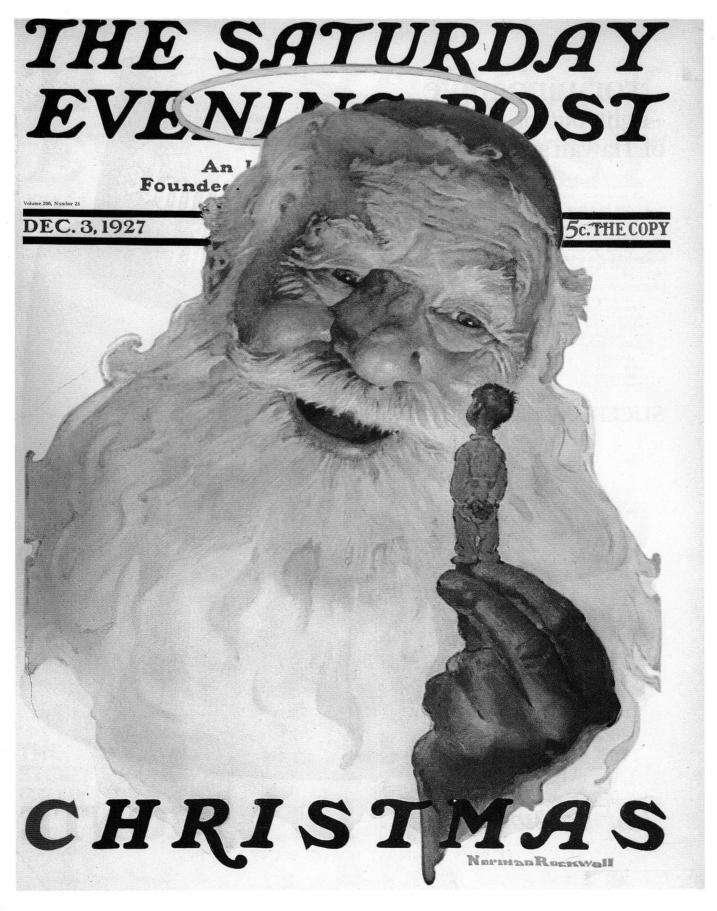

Christmas, 1927.
Post *cover, December 3, 1927.*

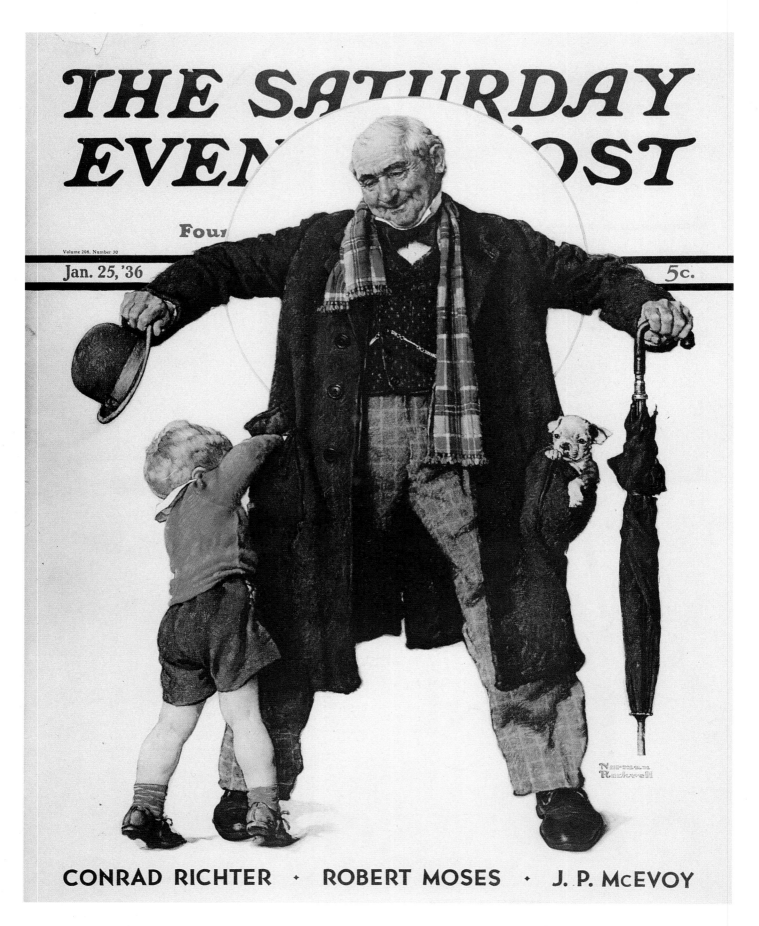

The Present.
Post *cover, January 25, 1936.*

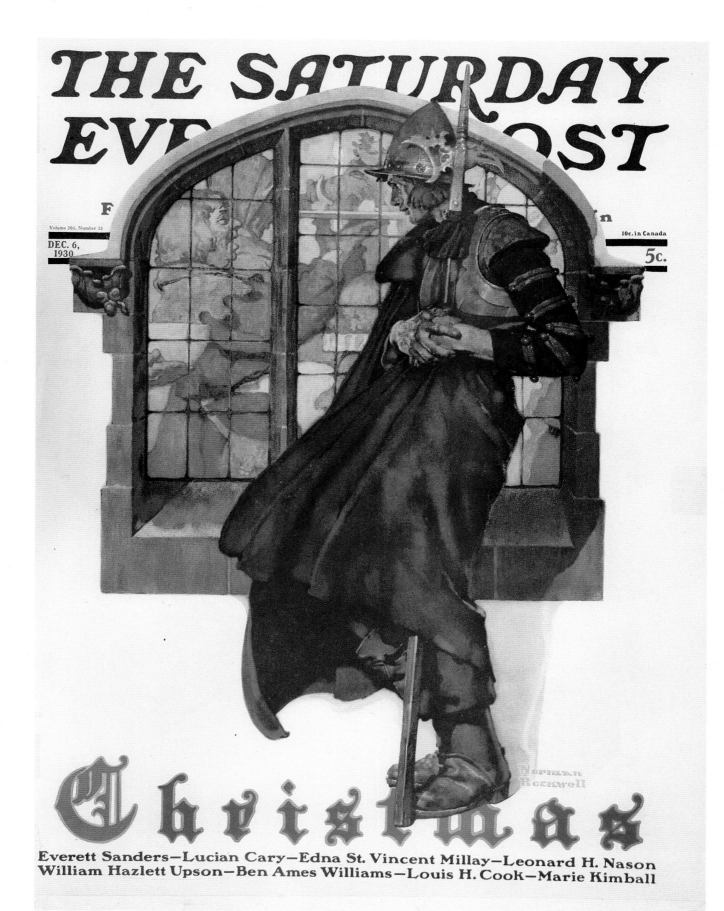

THE SATURDAY EVENING POST

Volume 201, Number 23

DEC. 6, 1930

10c. in Canada

5c.

Christmas

Everett Sanders—Lucian Cary—Edna St. Vincent Millay—Leonard H. Nason
William Hazlett Upson—Ben Ames Williams—Louis H. Cook—Marie Kimball

Christmas, 1930.
Post *cover, December 6, 1930.*

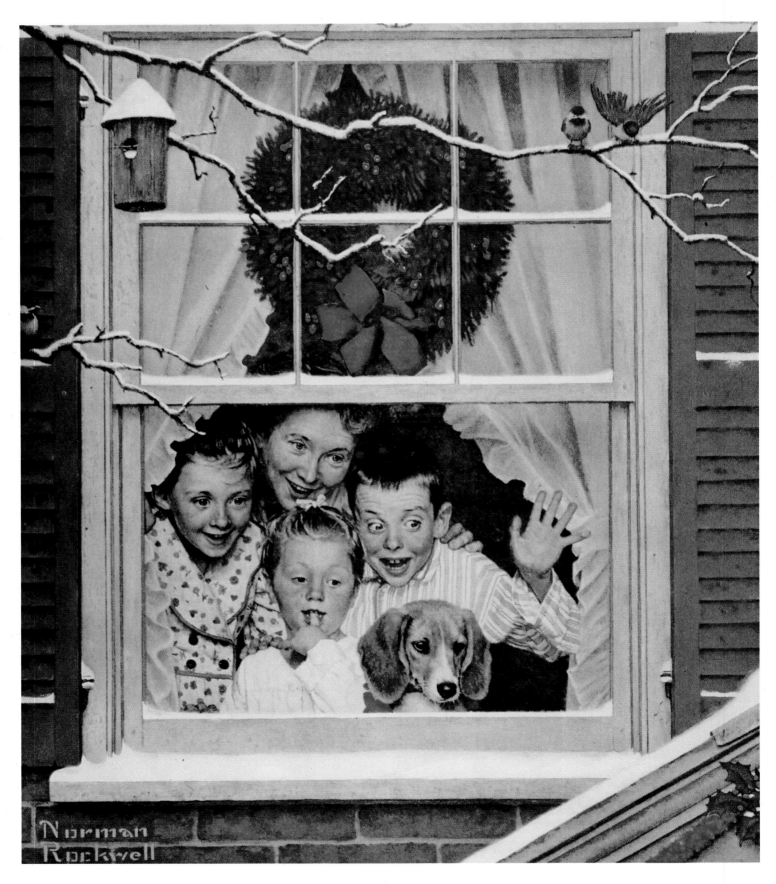

Family at the Window.
Plymouth ad illustration, December 22, 1951.

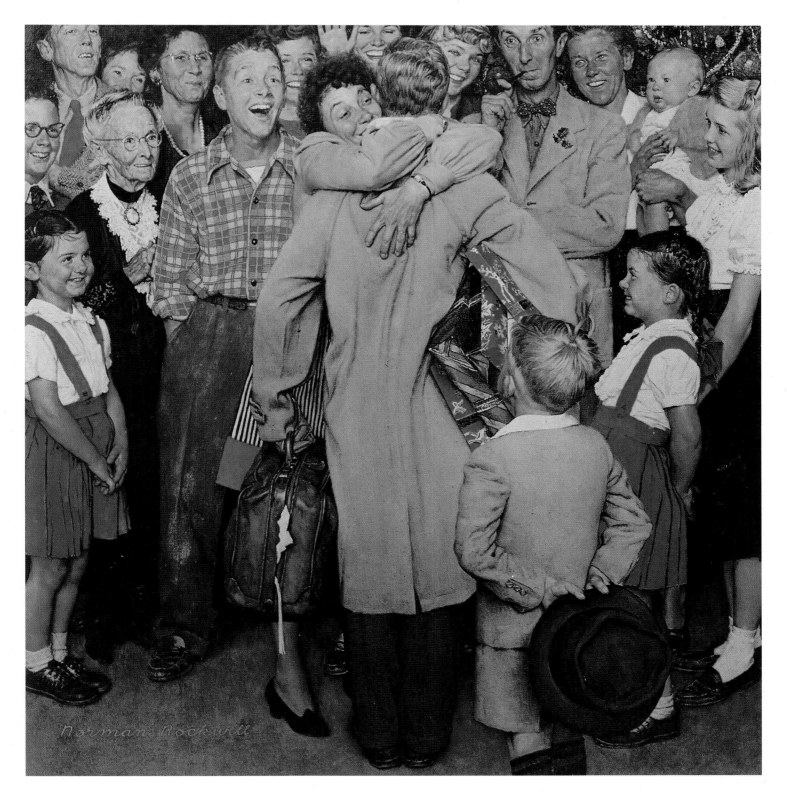

Homecoming.
Post *illustration, December 25, 1948.*

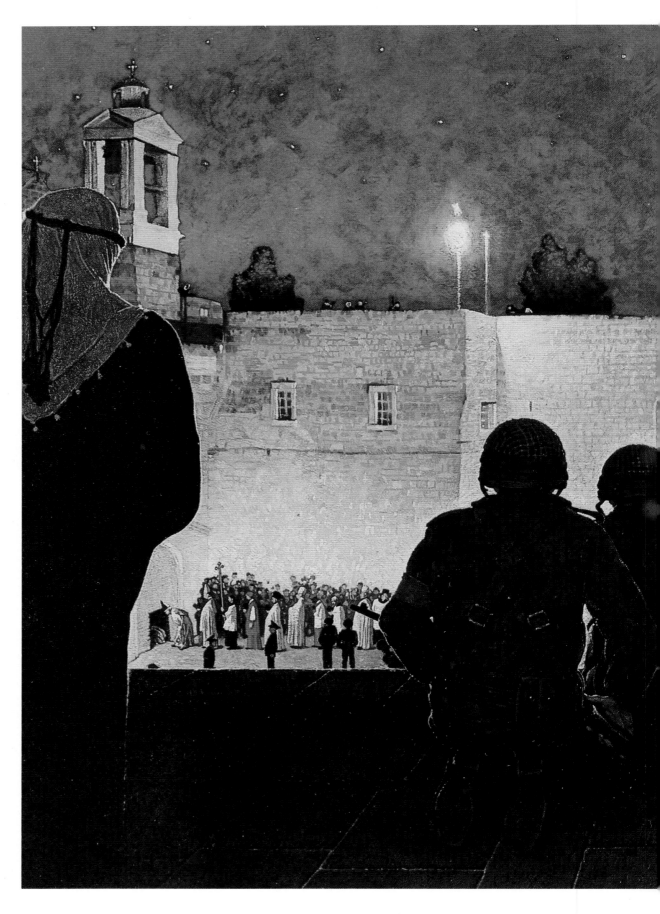

Christmas Eve in Bethlehem.
Look *illustration, December 26, 1970.*

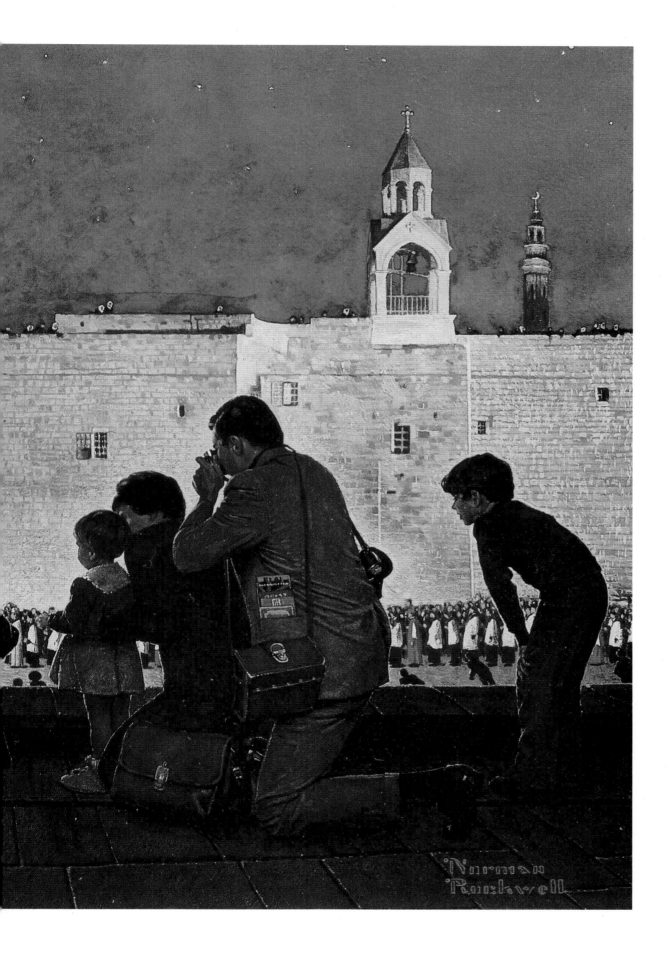

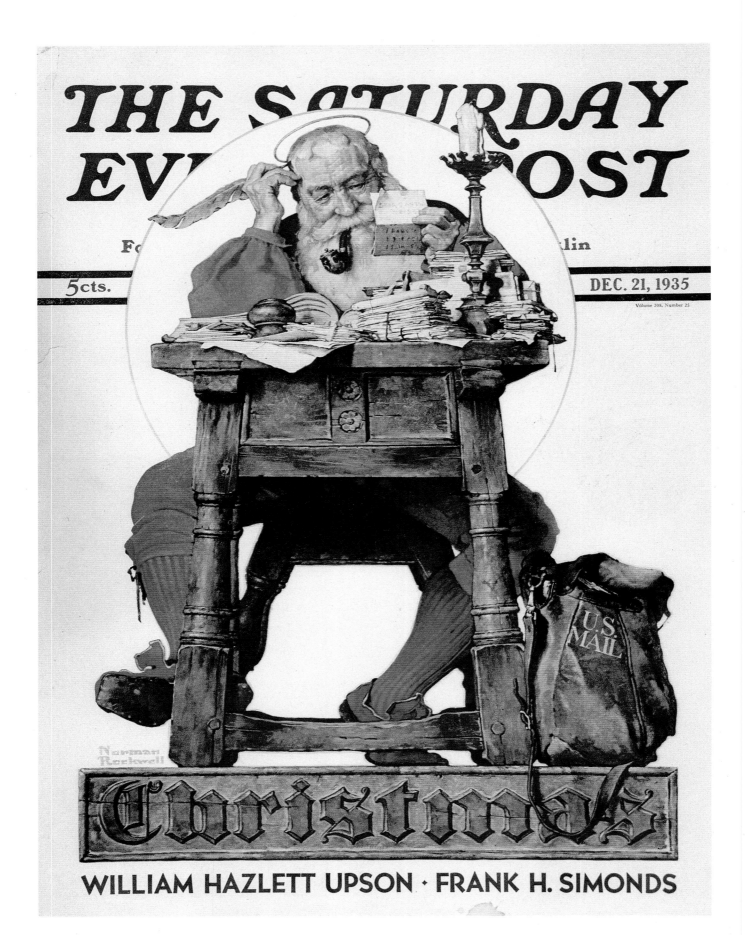

Christmas, 1935.
Post *cover, December 21, 1935.*

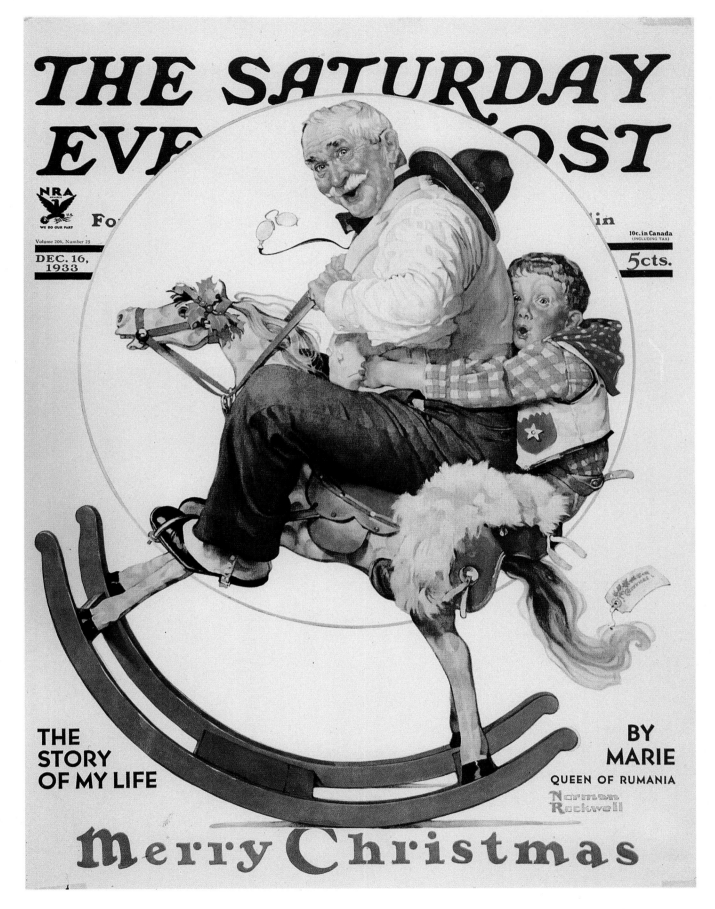

Merry Christmas, 1933.
Post *cover, December 16, 1933.*

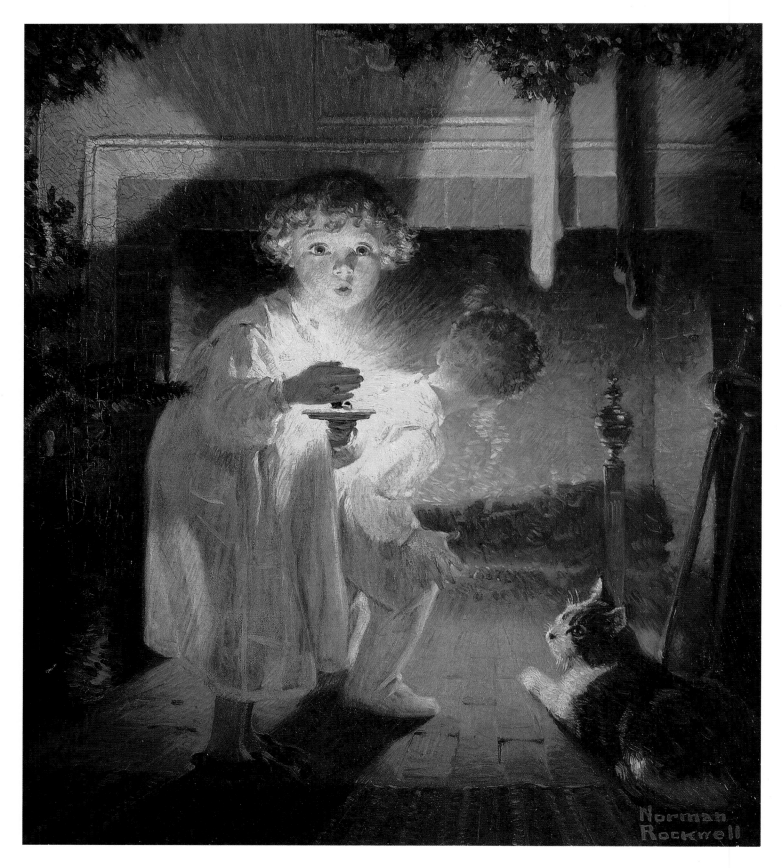

Is He Coming?
Life *cover, December 16, 1920.*

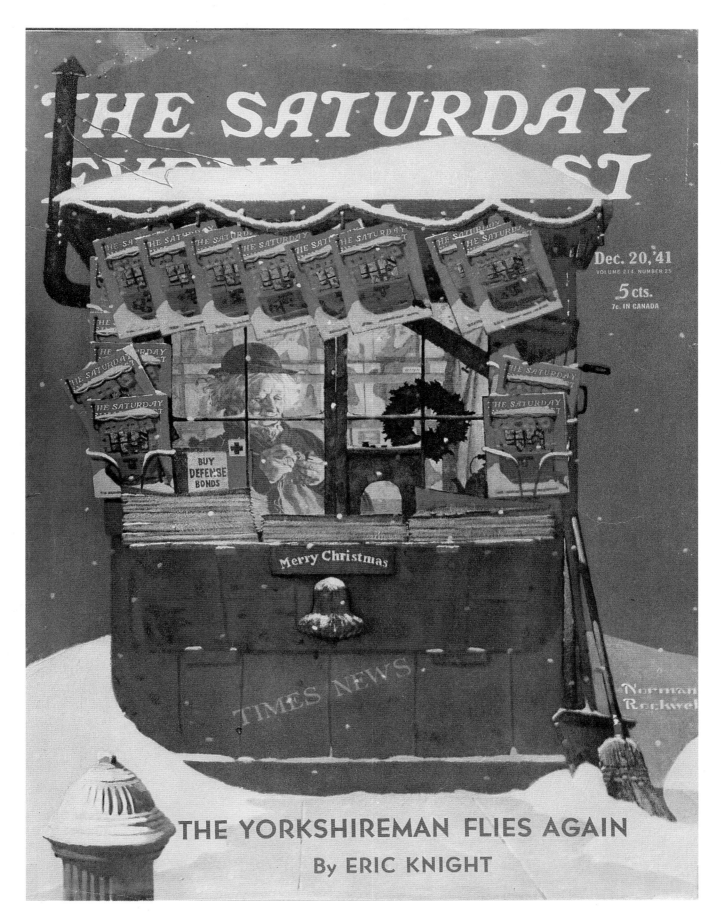

News Kiosk in the Snow.
Post *cover, December 20, 1941.*

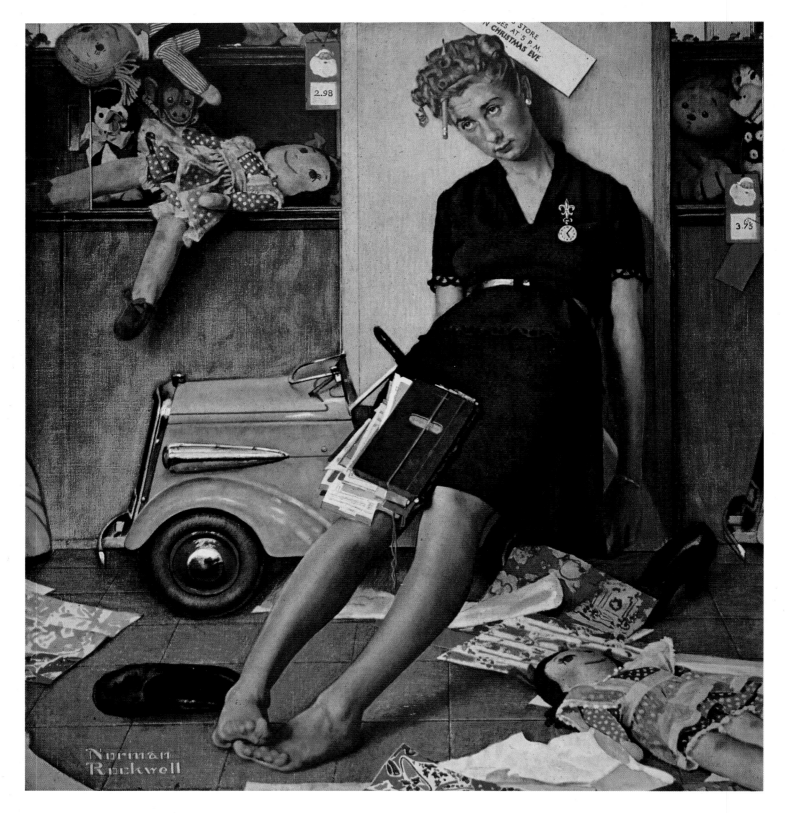

After the Christmas Rush.
Post *cover, December 27, 1947.*

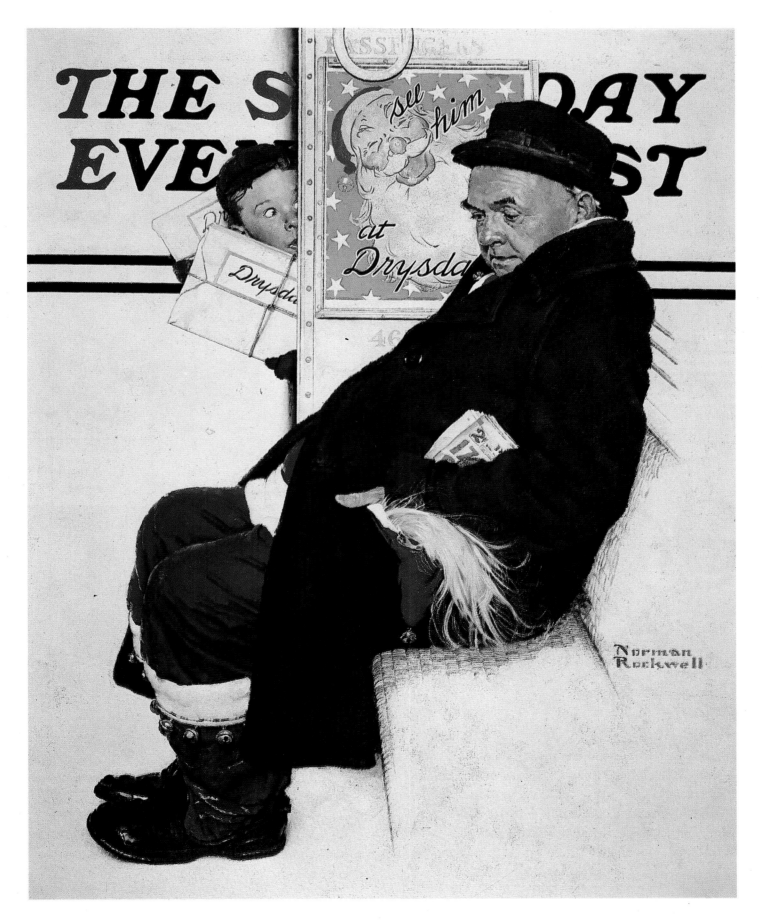

Santa on a Subway Train.
Post *cover, December 28, 1940.*

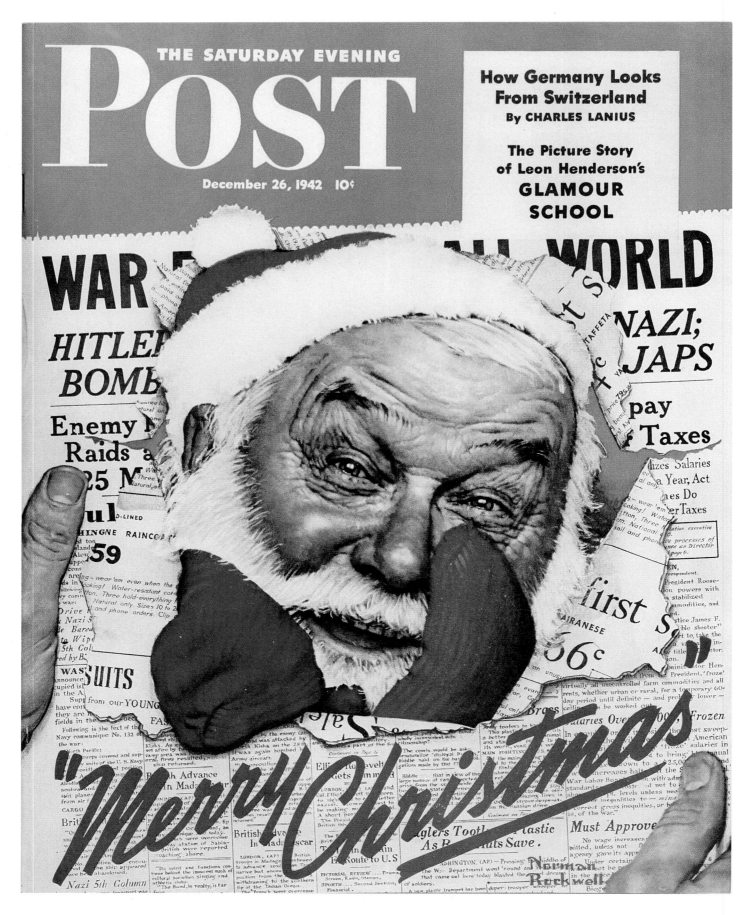

Merry Christmas, 1942.
Post *cover, December 26, 1942.*

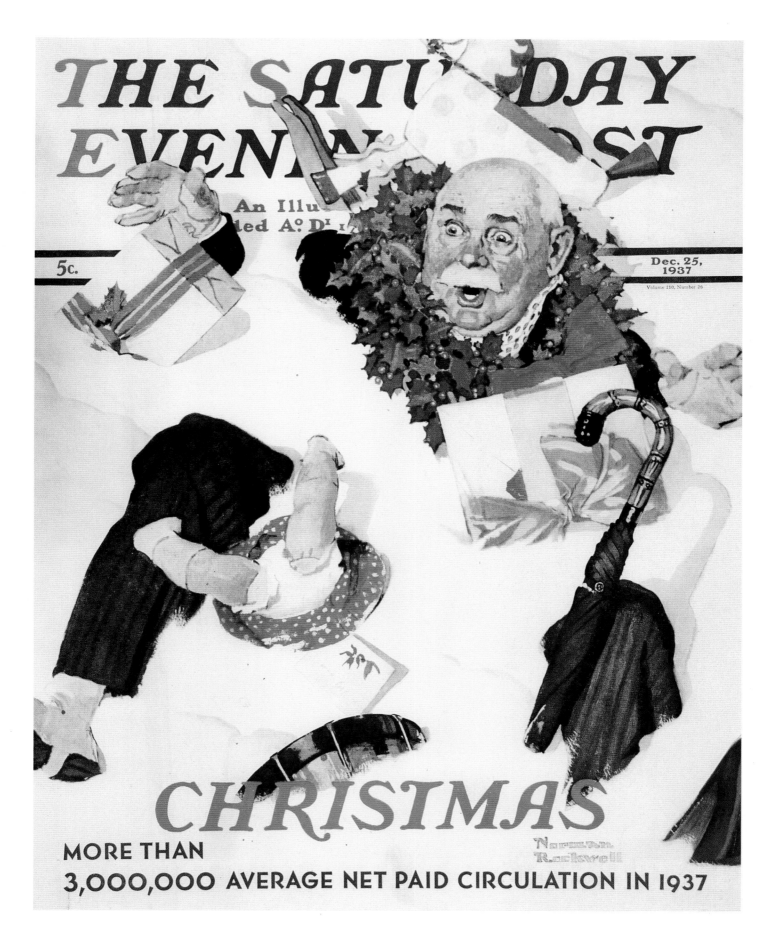

Christmas, 1937.
Post cover, December 25, 1937.

INDEX OF COLOR PLATES

Acknowledgments

The author and publisher would like to thank the following people who helped in the preparation of this book: Rita Longabucco, who did the picture research; Don Longabucco, who designed it; Barbara Thrasher, who edited it; and Thomas M. SerVaas, who photographed the plates. Special thanks are due Thomas Rockwell, Estate of Norman Rockwell, and Steven C. Pettinga, *Saturday Evening Post*, for their invaluable assistance and advice.

Picture Credits

The Bettmann Archive: 1, 6(top), 15(top left, top right), 19, 22, 23, 24.
Boy Scouts of America: 13.
The Norman Rockwell Museum at Stockbridge: 25.
Saturday Evening Post: 14.
Mike SerVaas: Front cover, back cover, 8, 9, 11, 15(bottom), 18, 19, 21.